EXTRAORDINARY
Women Conservationists
OF
WASHINGTON

MOTHERS *of* NATURE

DEE ARNTZ

THE
History
PRESS

Published by The History Press
Charleston, SC 29403
www.historypress.net

Front cover, bottom: Sea stacks at sunset with wavy patterns of wet sand in the foreground and dramatic clouds above, Second Beach, Olympic National Park, Washington. *Courtesy of Ethan Welty.*
Back cover, top: Sunlight is turned orange by smoke from a nearby forest fire rising over the beautiful alpine basin at Tapto Lakes, North Cascades National Park, Washington. *Courtesy of Ethan Welty.*

First published 2015

Manufactured in the United States

ISBN 978.1.62619.759.6

Library of Congress Control Number: 2014953386

Notice: The information in this book is true and complete to the best of our knowledge. It is offered without guarantee on the part of the author or The History Press. The author and The History Press disclaim all liability in connection with the use of this book.

To all the women who inspired me and all the men who stood with them.

CONTENTS

FOREWORD

Whenever I fly across our state, I always choose a window seat. Even when it's a bit cloudy, I can see the magnificent panorama, the many green cloaks of ancient forest and wild rivers dancing in the sun, the sparkling lakes and always those great mountains, ice-gleaming from north to south on each side of the Sound.

I get goose bumps, really, when I look at a map, preferably an ordinary state highway map. And there they are, what I term "those precious green areas"—the Nisqually Delta, a most wonderful tapestry of the three national parks and over one million acres of wilderness.

Every valley, every forest and river, every meadow tells a story, holds a memory. And always, these are tales of how just one person or a group of persons so loved that place that they were willing to stand up for and defend it. That is what this book is all about. About those wonderful "Mothers of Nature"—the determined, caring and savvy women of Washington State who stepped forward and became the teachers and inspirational leaders of so many of us during those difficult times.

This is a great book, long overdue. It tells powerful stories. Because of those special "Mothers of Nature," our state is ever so much more beautiful. Where would we be now if they had not stepped forward, spoken out and taken action when everything was at stake back then? Whenever I so wonder, back come those goose bumps!

I know because I was there. People like Polly Dyer, Emily Haig, Helen Engle, Joan Thomas, Hazel Wolf and many others became not only my teachers and indefatigable leaders but also my strong friends.

My feelings for the green spaces these women saved have always been awe and appreciation. Now I also have a profound joy that so many of them remain protected by law. Forever.

BROCK EVANS
Washington, D.C., and Seattle
August 2014

Acknowledgements

Many members of the conservation community helped and supported me in writing this book from its beginning in 2002. Interviews with more than seventy people provided invaluable and often unpublished information that is the backbone of this book. Special thanks go to Estella Leopold, who made several key suggestions, and Rod Brown, who offered invaluable insights. Bríd Nowlan worked with me throughout with editing and research; I couldn't have done it without her. Jonathon Cobb, my final editor, was masterful. Hilary Hilscher offered early assistance. My husband, Bill, supported me the whole way through.

UP, UP AND AWAY

We have often lamented…that the history of the accomplishments of women does not survive past the memories of those who lived them.
—*League of Women Voters*

In the interest of narrative simplicity, writers of history often condense long struggles into a single moment and acknowledge a few well-known leaders—who, most often, are men.

Historians who have attributed achievements solely to men have obscured much of importance. Even today, many male contemporaries know women shared in the struggles but often cannot recall exactly what they did. In an essay entitled "Gender and Wilderness Conservation," Kimberly A. Jarvis explains how this has manifested itself in standard accounts of the American conservation movement:

> *Until the latter decades of the twentieth century, most scholarly and popular discussions of the conservation movement focused on the men who led the movement at national, regional, and local levels. Historians of the conservation movement analyzed the contributions and leadership roles of Theodore Roosevelt, Gifford Pinchot, John Muir…while leaving out key women from Susan Cooper to Mary King Sherman to Rachel Carson. Roderick Nash's* Wilderness and the American Mind, *which in many ways defined conservation history for decades, was typical in this regard, with an almost complete absence of women.*[1]

Women's contributions have at times been literally left out of important histories. To note just one example, in the campaign to protect Washington State's Olympic National Park, an otherwise exhaustive account mentioned Polly Dyer only once, as taking notes at a meeting with the U.S. Forest Service, yet she was a principal actor in this epic struggle.[2]

In this book, I tell the story of Polly Dyer, as well as those of Jolene Unsoeld, Joan Thomas and many other women who worked for environmental protection long before it became a mainstream endeavor. While the focus is on the state of Washington and on conservation, similar stories could, of course, be told across the land and in many other spheres of American life. In Washington, over four million acres of wilderness, including lands that form Olympic, North Cascades and Rainier National Parks, have been preserved with the leadership and concerted efforts of women as well as men, often with women in the forefront and in the largest numbers. Women in Washington have also worked tirelessly to mitigate the effects of rapid industrialization and its resultant toxins and, in recent decades, to manage the region's exponential growth that threatens to engulf so much of its open space and natural beauty.

WOMEN RISING

The Progressive Era, between 1890 and 1920, encompassed the first wave of feminism and closed with the passage of the Nineteenth Amendment to the U.S. Constitution granting women the right to vote. Washington had earlier, in 1910, become the fifth state to approve suffrage for women. Decades before, in 1871, Susan B. Anthony had helped to organize the Washington Woman Suffrage Association, and in subsequent years, other nationally known suffragettes traveled to Washington to join in the fight.[3]

The women's club movement buttressed the fight for suffrage in Washington, as in other states. The first women's club on the West Coast was formed in Olympia in 1883, and three years later, many of the women's clubs that had sprung up in Washington became affiliated with the General Federation of Women's Clubs. These women focused on the issues that concerned them. "In the Progressive Era," Jarvis explains,

public-spirited women began to turn to the social problems of the day—poverty, education reform, poor sanitation. This work came to be referred

to as "municipal housekeeping." The definition was expanded to include protecting nature…

Club women worked together utilizing established networks to reach their conservation goals, whether it was to preserve natural scenery or historic structures, or to protect the headwaters of major river systems in their state or on the national level…Women employed their organizational abilities, developed during decades of charitable and reform work, to draw on grassroots support for the conservation movement. When women conservationists lobbied for the creation of parks and wilderness areas and for preservation of the lives and habitats of various species, they could draw upon networks of similarly situated women across the country.[4]

By the first decades of the twentieth century, writer Stephen Fox found large numbers of women had become committed to the cause of conservation. The General Federation of Women's Clubs, with two million members, formed a Committee on Forestry and Irrigation in 1902 to address such concerns. Mary Belle Sherman, president of the federation from 1914 to 1920, sent out so many personal letters urging the establishment of the National Park Service that she became known as the "National Park Lady." The General Federation of Women's Clubs together with the National Association of State Garden Clubs of America increasingly linked local, state and regional women's organizations into a huge network of women willing to contribute their time and effort to their issues of concern.[5]

The battle to save the Hetch Hetchy Valley of California's Yosemite National Park in the opening years of the twentieth century, led by the Sierra Club's John Muir, was one of the first instances where women in large numbers publicly backed a conservation effort, in this case, to block a proposed dam that would flood the valley. It coincided with another conservation effort in which women played a major public role: the ultimately successful campaign organized by two women and the Massachusetts Audubon Society to ban the hunting of birds for feathered hats. As in many other campaigns, women of that era wrote letters, lots of letters: a national mailing list with thousands of people willing and anxious to write letters was a formidable weapon indeed.[6] As another indicator of women's involvement, over half the members of the National Parks Association, an organization dedicated to supporting the conservation objective of the National Park Service, were women. And in 1948, the historian Bernard DeVoto commented that "the strongest single opposition" to threatened commercial inroads on the Olympic National Park came from women.[7]

Fay Fuller dressed to climb Mount Rainier. *Rainier National Park.*

On the rugged frontier, women participated in outdoor activities such as hiking and climbing, which often stimulated interest in environmental protection. Fay Fuller, a schoolteacher and social editor of her father's paper (Tacoma's *Every Sunday*), became, on August 10, 1890, the first woman to climb Mount Rainier. Her biggest problem was what to wear—a thick, blue boomer suit and boys' shoes with screws pounded into the soles turned out to be the solution. Society women declared her an outrage for immodesty,[8] but many women nevertheless followed her lead. As part of the Alaska-

Yukon-Pacific Exposition, for example, a party of women climbers reached Rainier's summit in 1909.[9]

In the last decades of the nineteenth century and the first decades of the twentieth, a farsighted few had begun to speak out against the swift destruction of old-growth forests and wilderness. Their developing philosophy of nature became the antithesis of a frontier attitude that sought to subdue nature to provide for human safety and wealth without concern for reforestation. George Perkins Marsh (1801–1882), John Muir (1838–1914) and Aldo Leopold (1887–1948) were early prophets of the need for environmental protection. Among those who eventually joined their forces, many were women—women whose voices have been all too easily forgotten, with the sometime exception of Rachel Carson. The existing historical references to women can only hint at their importance in behalf of conservation. Women exerted influence not only directly through their conservation movement activities but "also in their homes, on their husbands and families, in subtle ways neither recorded for posterity nor made public at the time."[10]

WASHINGTON WOMEN AND THE SECOND WAVE OF FEMINISM

If the first wave of feminism focused on women's suffrage, the second wave, from the 1960s to the 1980s, saw women in large numbers seeking credibility and parity in the workplace. Legislatively, an important symbolic moment occurred in 1972 when the U.S. Congress passed the Equal Rights Amendment, or ERA, to the Constitution. The following year, the Washington state legislature ratified it, though to this day it remains three states short of passage.[11] In July 1977, Washington State women came together in the town of Ellensburg to formulate a plan of action and elect delegates to a national forum established through the International Women's Year Commission. The Northwest Women's Law Center was formed the following year, and the year after that, Washington Women United was established to promote equal rights through legislative action, education and networking. These developments were indicative of the growing influence of women in civic and political affairs, and they coincided with an expanding Washington environmental movement. The coincidence of these currents made it possible for some notable Washington women to achieve leadership positions in both fields.

Above: This 1977 International Women's Year (IWY) conference button represents the Ellensburg conference. *Washington State Historical Society*.

Left: Senator Karen Fraser remains a leader in the Washington State Senate. *From the Office of Senator Fraser*.

The careers of two quite different Washington women, Karen Fraser and Judy Turpin, are indicative of the growing role of women in Washington conservation and political affairs. Fraser gave a brief synopsis of her early life in an interview:

> *Born and raised in Seattle, went to public schools in Seattle, went to the University of Washington, have a BA in sociology, got a Ford Foundation legislative internship after that, and so that's how I became initially acquainted with the legislative process. And then I went back to University of Washington,* [where] *I got a master's degree in public administration…* [T]*hen I started doing legislative liaison work for state agencies, initially with the Highways Department, and then the Community Development Department, and then the Employment Security Department…* [W]*hile I was working as a state employee, I started to become involved in local government and other political affairs, too, particularly the women's movement.*[12]

Fraser developed an early interest in the outdoors and began hiking with her father in her teenage years. Her interest deepened when she moved to the state capital in 1967 and signed up for a mountain climbing class. "I've hiked all over the Cascades, all over the Olympics," she said. "I've hiked the Chilkoot Trail in Alaska and the Yukon, and my husband and I have been on two treks in Nepal, in the Himalayas."

In the early 1970s, Fraser served as the statewide legislative coordinator for the National Organization for Women and participated in the Women's Political Caucus, which endorsed local and statewide candidates. Though women were increasingly active, they were at the time still fairly rare as office holders. In 1973, however, Fraser was elected to the city council in Lacey, a town on the edge of Olympia, and in 1976 became its mayor. The following year, she was one of the delegates to the state International Women's Year conference in Ellensburg.

Fraser went on to serve two terms in the state house of representatives and then, in 1992, was elected to the state senate, where she remains as of this writing. Throughout her career, she has pursued a philosophy akin to that of Aldo Leopold, who saw people as part of the larger community of life and responsible for the environmental consequences of their actions:

> [P]*eople are part of the environment; our bodies are composed of the environment; we're dependent on the environment for drinking water, for food, for medicine, for shelter, for our economy, too…So when you chair*

the Environment Committee, which I did in the senate for many years, you see this very intensely, that [corporate] interests come and they have zero interest in reducing toxics, because it's going to cost them some money, or they're going to have to change their manufacturing. They do not at all want to consider the fact that toxins in babies create lifelong health problems…[T]oxins lead to all kinds of health diseases and shortened life—that's thoroughly documented—but they don't want you to think about that. Instead, it's the economy versus the environment, people versus the environment.

It's really people versus people, because people who don't want to protect fish are harming the livelihood of people who depend on fish, to say nothing about cultural and social and recreational values.

Judy Turpin, by contrast, got started in policy and environmental issues later in life and through the American Association of University Women (AAUW):

I had a two-year-old, and when I found myself waving "Bye-bye" to an adult friend, I said, "Wow, I'm being 'toddlerized.'" So I went and joined the AAUW. The branch here needed a legislative chair, so they tapped me to do it. Then they said we could send somebody to the Puget Sound Council of Governments through the citizen participation committee, so they sent me.[13]

In the early 1970s, Turpin was one of a small number of feminists active in environmental issues. By the end of that decade, several women had established a formal group, Feminists and Friends of Future Forests, and hired Turpin to write a white paper on the state's responsibilities for its trust forestlands.

As a state officer of AAUW, Turpin represented the organization on constitutional and equal rights issues during International Women's Year activities, served as legislative chairman working closely with the lobbyist for the Washington Environmental Council (WEC) in Olympia and sat on the Washington Land Use Commission. In 1982, WEC hired her to lobby in Olympia, and she went to work for forest preservation.

THE RISE OF WOMEN IN WASHINGTON POLITICS

In the efforts of women nationwide to gain a full and equal voice in politics and public policy, including environmental affairs, the nonpartisan League of Women Voters has played a critical role. Washington's first two league chapters were established in 1920, and the organization has provided women with training in public policy issues, leadership and civic activism ever since. Through this work, the league has served as the catalyst for many who became active in environmental affairs, including, for example, Chris Smith Towne of Bellevue:

> *In '64, Boeing sent* [my husband] *to Los Angeles for four years, and L.A. in the mid- to late '60s was so smoggy. It was kind of the national air cesspool, and so I got really concerned about air pollution—here I was with three babies. And when we came back here in '68, I joined the league and got involved in the air and water pollution issues...Jocelyn Marchisio was the president of the East Side League of Women Voters and set up air pollution and water pollution committees, and they were really influential, in their league-lady way, in getting things rolling. They weren't firebrands. They weren't out there marching. But in their normal, let's-talk-about-it*

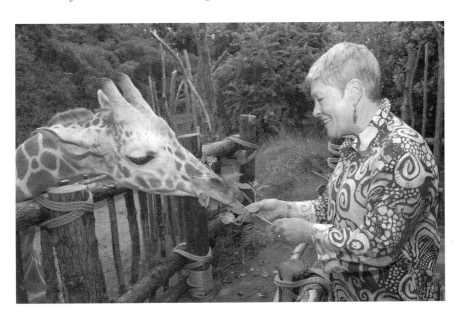

Chris Smith Towne feeds a giraffe at the Woodland Park Zoo. *Chris Smith Towne.*

way for two years, let's come up with a consensus. You take a position and then go work the legislature, the governor. They deserve a lot of credit; they [had] *a lead role.*[14]

Experience with the League of Women Voters gave many women the skills, courage and support to bypass, at least in part, the "old boy's network" in the 1970s when they began to consider seriously running for office. Individuals like Karen Fraser chose to begin at the local level while Nancy Rust and others moved right into the state legislature. Women were throwing their hats in the ring for state offices of auditor and superintendent of public instruction as well as the traditionally "male" jobs of attorney general and lands commissioner.[15]

Many of the names we see on today's ballots reflect a culmination of political careers that began in small ways in the 1970s and 1980s. As Nancy Helen Fisher, a Democratic state committeewomen, has pointed out, "The strategy of women seeking elected office to gain civic leadership and also to accomplish goals for environmental protection would turn out to be very successful, especially in Washington."[16] So much so that by March 1992, the *Seattle Post-Intelligencer* could report that "Washington is near the top of national rankings for percentage of state senators who are women. Women serve as mayors of Spokane and Tacoma and they hold a two-thirds majority on the Seattle City Council."[17] Seven years later, of ninety-eight house members in Washington State, thirty-seven were women, and of forty-nine senators, twenty-three were women—the highest percentage of female legislators in the nation at the time.[18]

Here is how Karen Fraser, in 2002, reflected on this remarkable shift in the context of the times:

When I go to regional or national conferences, people ask, "Why is Washington such a leader?" Because we're now the first or second in terms of numbers—the proportion of women in political office…But it occurred to me we are in danger of losing the ability to answer the question, to know what happened and why it happened [unless we document the history]. *It was a movement, and so it had many streams flowing into the great river of the movement.*

WOMEN AND THE GREAT ERA OF CONSERVATION

One of the advantages women typically had over men in their support of conservation and other environmental causes in much of the twentieth century stemmed from the few chances they had to achieve leadership in business. In the words of Rosalie Edge, "Most of the conservation measures are so closely related to business that it is sometimes difficult for men to take a strong stand on the side of the public interest. But women can and should."[19]

As the twentieth century progressed, women's roles in conservation nationwide became more pronounced. In Washington State, for example, during the great era of environmental legislation from 1965 to 2005, women were prime movers. Over those forty years, the most important laws that protect the state's forests, shorelines and waters were put in place. In these crucial battles, women as well as men were generals, field marshals and foot soldiers. Joan Thomas, founding member of the Washington Environmental Council, drafted the far-reaching Shoreline Management Act of 1971, for example; Sheri Tonn founded Citizens for a Healthy Bay, a group dedicated to cleaning up one of the biggest toxic waste sites in the country, Commencement Bay; and Bonnie Phillips of the Washington Ancient Forest Campaign helped save the last of the state's ancient forests.

Women in these decades often became leaders because they were there and were willing to do the work. Men were lawyers, engineers and state government professionals. Since women were effectively denied access to those professions for decades, they filled available niches in the environmental movement as well as in other voluntary campaigns. They founded organizations, drafted and helped pass laws, sponsored initiatives and educated and engaged voters. Until the 1980s, women, for the most part, were volunteers—volunteer committee chairs and volunteer presidents.

Rod Brown, former president of the Washington Environmental Council, said of his experience with early female environmental activists:

> When I first started out, I thought a lot of environmentalists were just volunteers, right? That's what we mostly are, is volunteers. And I sort of equated volunteers as, well, you just do it a little bit whenever you feel like it, and one of the things I realized looking at [the women involved] is…you can volunteer just a few hours, if that's all you have—but if you want to be a leader, that's a profession just like any other career path that you might have, and you need to treat it with the seriousness and hard

work of a professional, and I thought, oh my goodness, they're working a lot harder than I am. I'd better, you know, ramp up my game…[O] ne thing I noticed is they treated it with a [high] level of seriousness. It wasn't their only serious activity, but you could tell it was one of their high priorities…[T]he other thing I noticed is that they emphasized building the teams to get the results that they wanted.[20]

Of the early decades of this era, Marcy Golde, former chair of the Washington Environmental Council's Forest Committee, commented:

There were not many men who were into environmental things at that point because it was low salary, low prestige, and women moved in there because that was a place where they could take the lead and because they believed in it and wanted to do it, and because they saw the relationship to the long-term world for their children. I think that that's really part of what brings women to that. But it also was an open space, a niche…Women moved into that niche and exploited it very, very effectively.[21]

THE STATE AND THE NATION

Other states also had strong conservation leadership—especially Wisconsin and New York.[22] But Washington State was unique in the strength and coherence of its conservation community and its political reach. Here women rose in politics to hold the top-three elected offices—governor (Christine Gregoire preceded by Dixy Lee Ray), senator (two, Patty Murray and Maria Cantwell) and lands commissioner (Jennifer Belcher). And there were female leaders in the state legislature—for example, the chairs of legislative committees, known collectively as the Steel Magnolias, and a state senate majority leader (Jeannette Hayner). Some contributing factors in this amazing achievement may be the relatively small size of Washington and its geographic position in the Pacific Northwest, where at least three national battles to conserve wilderness, national parks and the last ancient forest were fought; these were national crises playing out at the local level, and women responded.

Women also helped found at least ten major environmental organizations in the state: Washington Environmental Council (WEC), Puget Sound Alliance, Washington Conservation Voters, Washington Wildlife and Recreation Coalition, Washington State Wilderness Society, the first state

chapter of the Sierra Club, People for Puget Sound (now folded into WEC) and an array of Audubon chapters. Many women did not remain in low-level positions in these and other nonprofit organizations but kept moving up. By the end of the twentieth century, female conservation leaders had become a match for the leaders of the for-profit world.

One common path to leadership for women began with secretarial skills. Polly Dyer, a pioneering advocate for wilderness protection, epitomizes this early approach to attaining leadership. She was part of a core group who in the 1950s realized that wilderness—not only the existence of wilderness but also access to wilderness areas and the very concept of wilderness—was fundamental to American culture and values. A secretary by training, Polly initially served as the secretary for most of the committees she was on. Invariably, she moved up to chair when the appointed man had to step aside due to conflicts with work. She accepted leadership, testified at congressional hearings and led many groups to victory. Still, it was not easy to make her way in a world where men were given preference. Small slights were normal, such as not being invited to an important fundraiser unless all the men on the committee were otherwise occupied and couldn't go.[23]

"What motivated women to crusade? Courage? Brashness? Naïveté?" Helen Engle once asked in a publication honoring the women of the Audubon Society. She answered, "Our women environmental leaders based their stand on serious study of the issues, characterized by enthusiasm, optimism, and perseverance. Plus that firm conviction of the rightness of saving the living world."[24] Fifty-two women and eighteen men who were interviewed for this book gave similar answers. One of the most commonly mentioned qualities believed to contribute to the success of women as environmental leaders was perseverance. As one person put it:

> *What I notice about people like Vim* [Wright] *and Joan* [Thomas] *and Maryanne* [Tagney-Jones], *I think there was a dogged determination to not take no for an answer...I just was always amazed at how these women would never take no for an answer. They would always go, "What do you mean no?...We're going to come at you again and again until you say yes." So I think they had a way of wearing people down in government, and that was very effective. I don't know if men would do that, to tell you the truth.*[25]

Another characteristic identified was commitment to an overarching goal—a healthy environment and a future for all children: "The conservationists I knew in the fifties and sixties never thought in terms of

their own personal recognition. The recognition was coming, even in the fifties, but they were not doing it to be recognized. Everybody was doing it because of the cause—dedication to wilderness and national parks."[26]

A third characteristic mentioned was dedication to building teams and a network of support, especially in the early years of the movement:

> *I noticed that* [these women] *emphasized building the teams to get the results that they wanted. They seemed much less ego-driven—a stereotypical male in the business world is ego-driven: "I'm going to be the CEO of this organization, and everybody get out of my way." And the three women I just mentioned* [Joan Thomas, Vim Wright, Marcy Golde], *not one of them wanted any of it to be about them, about them being the leader or recognized as the leader. It was more, let's build this team to be highly functioning and highly effective and get the result for the environment that we want.*[27]

Civility and empathy that allowed the women involved to reach across acrimonious divides and out to other important groups was a fourth quality identified: "It's seeing the whole and understanding what's *really* going on. That's what I've learned from women, from other women leaders and women in the environmental realm, is the story behind the story. You often have a dispute about something, that stated dispute on the surface, which is not the *real* dispute, and I've learned about that."[28]

The same characteristic seen from a different angle came through in another interview:

> *I think we're, by nature, the nurturing sex. We're biologically designed to be nurturing, and I think that's part of good earth-keeping...* [W]e have *a natural inclination to protect life and preserve life, which is wildlife, and also to provide food. I think some of us, anyway, can be good at disarming people or making people less afraid of change, that women can be less intimidating than men. It tends to be a friendlier, less combative environment when women are involved.*[29]

TELLING THE STORIES OF WASHINGTON'S WOMEN ENVIRONMENTAL LEADERS

I worked with many of the women described in the pages that follow over the past thirty-plus years. In the early 1990s, I joined the board of the Seattle Audubon Society, for which Hazel Wolf was secretary. While taking a course at the University of Washington's Environmental Institute from Estella Leopold, professor of paleobotany, I joined in the final struggle to save the Nisqually Delta and worked closely with Janet Dawes, Joan Thomas and Helen Engle. While on the Seattle Audubon Conservation Committee, I took an interest in wetlands protection and with Barbara Douma built the Washington Wetlands Network (Wetnet) to link and strengthen wetlands advocates around the state. I joined Joan Thomas and Vim Wright on the Washington Environmental Council Board of Directors. Through these and other activities, I learned about the many influential female environmental

This map of Washington shows national parks, federal forests and toxic sites. *Adam Kuglin.*

leaders who were unknown to a wider public, and the conviction grew that their stories should be told and, if feasible, in their own words.

We are blessed that women have relatively long life spans. Although Emily Haig, Hazel Wolf, Nancy Thomas, Vim Wright and, recently, Joan Thomas have died, Helen Engle, Polly Dyer and others are still with us as of this writing. All, in any case, will live on in their accomplishments, teaching and friendships. For this book, I not only conducted interviews with the women themselves and the men who worked closely with them but also consulted the treasure-trove of papers donated by many individuals and organizations to the archives at the University of Washington Suzallo Library and, of course, secondary sources. Still, facts were not always easy to find or verify. Many of the usual sources, such as newspaper articles and books, often leave women out or gloss over their contributions.

Men, of course, are not absent from this story—they're just taking a back seat for a while. Many accomplished men worked side by side with the women portrayed here—Thomas Wimmer, Rod Brown, David Bricklin, Joe King and William Ruckelshaus, to name just a few. This book, though, is focused on the women, their stories and the issues they addressed. The ensuing chapters roughly follow a historical timeline. Each presents one environmental issue and highlights one or more of the women instrumental in tackling that issue.

PRESERVING NATIONAL PARKS AND THE WILDERNESS

POLLY DYER AND EMILY HAIG

From beginnings as secretaries, they became conservation icons. Throughout much of the twentieth century, Polly Dyer and Emily Haig fought to preserve Washington State's trees and wilderness. The amazing results of their efforts, together with those of the many women and men who worked alongside them, are (among other accomplishments) two national parks and five million acres of protected wilderness. This chapter tells their stories in the larger context of their times.

As the nineteenth century closed, more than half the nation's original forests were gone—cut down to build homes and clear fields for agriculture. The wildness of America's landscape that had mesmerized and challenged early settlers was fast disappearing. Among the few areas still intact was a thin band of ancient coastal forests stretching from California to the Pacific Northwest, the scene of what journalist William Dietrich called the "final forest." Next stop for the loggers: the Pacific Ocean, or so it seemed. Imminent massive deforestation there became a cause of national concern, at least outside the timber industry.[30]

In Washington State, the lush lowland forests of the Olympic Mountains sit on a wild peninsula bordered on the west by the Pacific Ocean, on the north by the Straits of San Juan de Fuca and on the east by Hood Canal and the Cascades, the mountains that form a ridge from British Columbia in the north to California in the south. Together, the Olympics and the Cascades were two of the last truly wild places in the continental United States.

Those alarmed by the rapid disappearance of wild places had begun in the waning decades of the nineteenth century to come together in local and

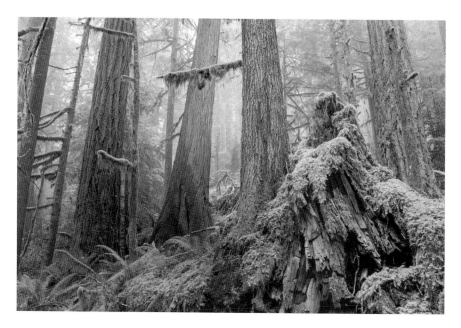

An old-growth forest located in North Cascades National Park. *Ethan Welty.*

national groups. In 1892, John Muir founded the Sierra Club to "make the mountains happy." The Mountaineers were formed in 1906 in Washington "to explore wild areas," and ten years later, the Seattle Audubon Society was formed. At the national level, several other organizations took shape that would also contribute to the conservation of Washington's forests, including the Emergency Conservation Committee in 1929 and the Wilderness Society six years later.

In the late nineteenth and early twentieth centuries, conservation was largely a man's world. Wilderness preservation, in particular, was identified as a masculine pursuit: after all, wilderness was rugged and dangerous, and visiting it required physical strength—or so the thinking went. Women were often simply not acknowledged in the fight to preserve wilderness, and the U.S. Forest Service and National Park Service were almost entirely staffed by men. Initially, women seemed to be interlopers in both worlds. But in fact, women were indispensable in the struggle to save wilderness areas, even as early as the 1890s in the campaign to protect the Mount Rainier region as a national park. Women formed the core of many of the nation's conservation movements led by men, such as those spearheaded by the Sierra Club and the National Audubon Society. Legions of women sat on committees, testified at hearings and wrote letters. They became the watchdogs and the conservation presence

on the ground. According to environmental historian Carolyn Merchant, "it was women's efforts that extended the appeal of the primarily elite male-led conservation movement and made it a mass movement. At the most basic level, recognizing women's contributions to the American conservation movement is essential to understanding the history of the movement."[31]

In their struggles to save Washington's forests, preservationists, men and women alike, faced a virtual wall of institutional, political and economic power. Throughout much of the twentieth century, the U.S. Forest Service and National Park Service were essentially at the service of big timber. Mining companies, with little evidence, were convinced that the mountains contained deposits of valuable metals, so they put their power behind the timber interests. The railroads and the tourist industry eventually joined the mining companies in their efforts while local chambers of commerce eagerly backed private commercial claims on public lands.[32] The Washington State congressional delegation also supported private economic interests over public preservation. Most of them understood the parable of killing the goose that laid the golden egg, but they wanted the gold there before it found its way into other pockets. Advocacy of preservation, by contrast, in its implicit questioning of the wisdom of an unfettered free market, was seen as un-American. Nevertheless, conservationists like Polly Dyer and Emily Haig would be remarkably successful in that sixty-year, David-and-Goliath battle to preserve the forests of the Olympic Mountains and much of the Cascade Range.

POLLY DYER: AT THE CUTTING EDGE OF WILDERNESS

Born Pauline Tokiel in Hawaii in 1920, the daughter of an officer in the U.S. Coast Guard, Dyer went to primary school in Seattle before moving to Connecticut, Maryland and then Florida, where she was able to squeeze in a secretarial course before the family was sent to New York and thence to Alaska. Dyer dates her love of wilderness to a life-altering moment as a young woman of twenty-five on Deer Mountain near Ketchikan, Alaska. As she looked out over the wilderness, a stanza from Edna St. Vincent Millay's "God's World" embracing nature's beauty and grandeur flashed into her mind.[33] On that same mountain, she also met the love of her life—a young man wearing a red hunting cap with a "Sierra Club Rock Climbers" pin, John Dyer. It was from him that she learned about both wilderness and conservation for the first time. After a four-month courtship, she and John were married in August 1945. She

joined her husband in his life as a mountain climber and conservationist and joined both the Sierra Club and the Alaska Sports and Wildlife Club. As she recalls, "I became the secretary [of the club] because I took shorthand."[34] This was her first, but not her last, stint as club or committee secretary. Her skills in shorthand and typing could have pigeonholed her as "just a secretary" in the then male-dominated conservation world and been a ticket to oblivion. But for Dyer, secretarial skills became her entrée to a long career as a brilliant, though often underestimated, conservationist.

In 1945, Dyer was a tall, lovely, dark-haired woman. When I interviewed her in December 2001, she was silver-haired but still a lovely woman. Dressed in a tailored jacket, Dyer welcomes you with a warm smile and a glint of humor in her eyes, ready to share her experiences. She has an incredible memory, which is fortunate for us all because she has a long history to remember.

In 1947, now in Berkeley, California, while John pursued his career as biological chemist, Dyer thought:

> *I had the philosophy that if I had to belong to an organization, I may as well do something for it. So I volunteered and ended up being the typist for the newsletter that was called the Sierra Club Yodeler…*[My husband] *had been vice-chair of* [the local Sierra] *Club Chapter before he went to Alaska and so he was… asked to chair the Education Committee for the San Francisco Bay Chapter. However, John had an illness…He was put to bed for four months. He couldn't serve, so the chapter president said, "How about your wife?" So I became education chair, which was basically* [showing] *sugarcoated slide shows.*

In 1950, John was offered a job in Auburn, Washington, and the couple moved north. The Dyers joined the Mountaineers and, more specifically, its conservation-oriented Public Affairs Committee, where Dyer was soon made, of course, secretary. This post led, in 1957, to her becoming the Mountaineer delegate to the Convention of the Federation of Western Outdoor Clubs. In addition to their work with the Mountaineers, in 1953, John and Polly Dyer, along with Patrick (Pat) and Jane Goldsworthy, decided to organize a Pacific Northwest chapter of the Sierra Club, the first chapter outside California. Pat asked Emily Haig, the veteran of Sierra Club action in California earlier in the century, to join them. David Brower, then executive director of the Sierra Club, came to Auburn to help organize the new chapter. The chapter encompassed Washington, Oregon, Idaho and British Columbia; even so, it was initially a hard scramble to gather fifty new members. It was

in 1953 that Dyer also began working in earnest to save the Olympic Mountains, a struggle that had begun years before but that had now reached a critical stage. Ever since the establishment of the national park there in 1938, various parties had been ceaseless in their efforts to shrink it or open it to logging, mining and grazing.

The Struggle for Olympic National Park

President Theodore Roosevelt had championed Mount Olympus as one of the last unexplored places in the West and had designated the Olympic National Forest as a national monument. As described by historian Douglas Brinkley, the Olympic Peninsula had a particular pull for Roosevelt—a four-footed namesake: "For a lover of big game, seeing a 700-pound Roosevelt Elk browsing in the lush primeval forest constituted an experience unequaled in North America. Mount Olympus, with glaciers descending its rugged slope, was to this national monument what Old Faithful was to Yellowstone."[35]

The president was able to create a national monument by executive order under the Antiquities Act of 1906. Ostensibly, this legislation was targeted for historic landmarks, but the definition was expanded to accomplish conservation objectives quickly and without divisive debate. The area protected was to be "confined to the smallest area compatible with proper care and management of the objects to be protected," so the next step for wilderness advocates was to gain the national monument lands status as a national park to ensure its permanent protection, especially its lowland river valleys, which timber companies were eager to log. A setback to conservationists' efforts came almost immediately. In 1913, President Woodrow Wilson shrank the boundaries of the monument by half. He was responding to pressure from park opponents allied with the Forest Service and the Washington congressional delegation at the time—all of whom believed these forests should be reserved for feeding the mills in Grays Harbor, not protected as wilderness. This issue would come up again and again even after the monument became a national park.

From Washington State, Irving Clark, a prominent and politically well-connected Seattle conservationist, led the opposition to the Forest Service and its allies. He was in touch with Irving Brant of the Emergency Conservation Committee (ECC), whose other founding members were Willard Van Name and the remarkable early female conservationist Rosalie Edge. Van Name, a scientist at the American Museum of Natural History, turned his 1932

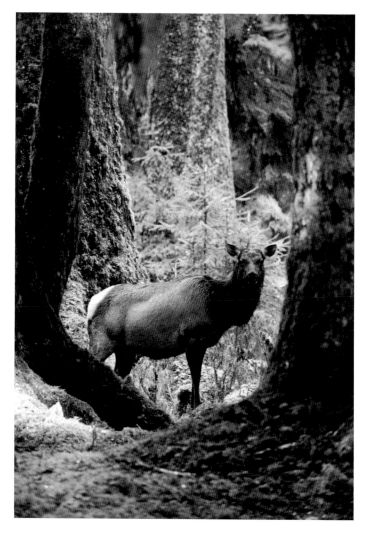

A Roosevelt elk is captured on camera in Olympic National Park. *Art Wolfe.*

scientific report on the area into a pamphlet entitled "Proposed Olympic National Park." Under the egis of the ECC with Rosalie Edge as the lead author, it was issued in 1934, the same year a new bill proposing an Olympic National Park was introduced in Congress.[36]

The proposed Olympic National Park—and later, the park land itself—became the subject of a vicious tug of war between those who believed that trees, especially old trees, should be cut and sold and those who wished to protect the area as a wilderness preserve. For its part, the U.S.

Forest Service concealed its motives in aiding the timber industry behind the following myths it helped to create:

- Old-growth trees, most hundreds of years old and many over three hundred feet tall, were riddled with insects and crippled by old age.
- The trees and minerals in the Olympics were desperately needed for the war efforts (initially for World War I and then for World War II) for a large fleet of wooden airplanes and for precious metals such as manganese.[37] (The need for Sitka spruce for airplanes never materialized and no manganese was ever found.)
- An Olympic National Park would lead to thousands of lost jobs, despite a Forest Service study that the national park would relocate only 172 families (860 individuals).[38]

In her work in behalf of an Olympic National Park, Rosalie Edge drew on her fearlessness and her ability to publicize issues nationally. A society matron from New York City, Edge had taken up the cause of conservation in her fifties when she realized that existing conservation groups, particularly the National Audubon Society, had formed alliances with gun manufacturers and hunters. As a result, the Audubon Society tolerated in its refuges the baiting of ducks for hunters, predator trapping and the extermination of nuisance birds, such as hawks. To take on these unholy alliances, Edge in 1930 sued (successfully) the Audubon Society to secure its mailing list in order to send out conservation information at odds with the "party line." Her mailing list eventually included thousands of conservation activists ready to write letters and phone their congressional representatives. By the mid-1930s, Edge had become perhaps the most powerful environmental activist in the nation.[39]

Irving Brant, a former editor of the *St. Louis News Dispatch* and a friend of and consultant to the secretary of the interior Harold Ickes, gained access to President Franklin Roosevelt to lobby for park designation. When Brant briefed the president on the duplicity of the Forest Service and the background of its proposals, Roosevelt decided to go to the Olympic Peninsula to see the realities for himself. The Forest Service tried to script the entire visit, even down to moving the markers for the proposed park to hide the inroads of clear-cuts already made in it. But forewarned by Brant, Roosevelt was heard to say as his car drove by, "Whoever is responsible for this should rot in hell!"[40] The timber industry and the two federal agencies continued to fight the Olympic National Park proposal right up to the final vote. However, Brant's strategy—to stay with the relatively modest proposed boundaries and to add a new provision that

allowed the president to add forests by proclamation—won out. Olympic Park Bill HR 4724, as amended, was passed in Congress, and in 1938, Roosevelt signed it into law. Of the Olympic valleys, only the Bogachiel was left out, and that was remedied by presidential proclamation in 1940 when FDR added 187,411 more acres to the park.[41]

The timber industry, despite this defeat, fought on. In 1947, several bills were submitted in Congress to cut out thousands of acres of virgin timber from Olympic National Park. Rosalie Edge published a third pamphlet, "The Raid on the Nation's Olympic Forests." The struggle to maintain the boundaries of Olympic National Park dragged on for decades with Polly Dyer and Emily Haig in the forefront. In 1953, Governor Al Langlie, who had not given up on shrinking the park, formed a committee heavily stacked with timber industry supporters to review its boundaries. Three conservationists were added to the committee after a special meeting with the governor: Bill Degenhardt, president of the Mountaineers; Emily Haig, president of the Seattle Audubon Society; and Rosamond Engle of the Seattle Garden Club. The predictable happened: Degenhardt couldn't get away from his job to attend meetings, so he asked Polly Dyer to take his place. Then the secretary of the committee found he couldn't make the meetings either, so Dyer became secretary. Brant described the committee's deliberations:

> *The Committee invited comment, held hearings, and argued for eleven months, then made two reports. The majority wrote one sentence: that the Secretary of the Interior should "designate two or more men of national standing in civic or land use planning to study all aspects of the Olympic National Park" and submit recommendations on boundaries or other aspects of management.*
>
> *The Governor refused to disclose the minority opinion signed by three women and two men…Mrs. Neil [Emily] Haig, Karl Hartley, Jack Hollingsworth, Mrs. John A. [Polly] Dyer, Rosamond Engle…At last on March 20, 1954, Langlie uttered one sentence "under the circumstances, I feel there is not enough crystallization of opinion among the committee members or among the public generally in this State, to warrant any further studies by a public agency of the State or Federal Government." Still he refused to disclose the minority report. Three weeks later the* Port Angeles Evening News *got hold of both reports and published them on April 13.*
>
> *The dissenters set forth their view in fourteen numbered paragraphs— championing the rain forests and other scenic wonders of the park, defending its territorial integrity, opposing cutting within it…It was not these opinions, however, that had caused Governor Langlie to suppress the minority report.*

The crowning blow was statistical. Of 307 persons who wrote to the committee during its year of activity, 300 were in favor of retaining the present boundaries...there was in fact crystallization with a vengeance.[42]

During the yearlong committee process and writing of the minority report, Dyer and Emily Haig became friends. Haig, already a major force in Washington's conservation battles in her own right and the person who had wrested agreement in the governor's committee that there would be a minority report, became a mentor to the younger Dyer. In fact, much of the success of Washington State's conservation groups can be traced back to Haig and her work methods. When she died in 1978, her obituary read like a history of Washington State conservationism.

EMILY HAIG: GRACIOUS LADY OF CONSERVATION

Born in California in 1890, daughter of a Sonoma County farm laborer and a mother who would soon be widowed, Haig at the age of nineteen had moved to San Francisco and become a stenographer working in real estate.[43] Her interest in conservation began in 1912, when she joined the Sierra Club, and shortly thereafter joined John Muir in the fight to stop the proposed dam on the Hetch-Hetchy River. The writer Robert Michael Pyle recalls his friendship with Haig and the significance of her history:

Audubon meetings took place around the immense dining room table in the Capitol Hill home of Emily Haig, Grand Dame of Seattle conservationists; Sierra Club retreats also revolved around Emily, as we congregated in her country cabin on Hood Canal. When we broke for coffee and cookies at Emily's sideboard, or to gather dinner from her own oyster beds, I gazed on her eggshell face with its honeysuckle smile and conjured on this one astounding fact: Emily Haig had belonged to the Sierra Club in San Francisco when John Muir was still President. She had known the man...I recall her telling of his bright eyes and his youthful stride and spring, and the indefatigable energy that he brought to bear on his conservation battles.[44]

A busy "club woman" in San Francisco, Haig became even more active in similar work when she and her husband, a timber broker, moved to Seattle in 1923. After her husband died in 1946 and her children had grown, Haig started

to take a more active role in Washington conservation groups. Over the ensuing thirty years, she emerged as a multifaceted conservation leader. President of the Seattle Audubon Society and active in the Mountaineers, she led field trips, gave talks and wrote articles about birds and conservation, including a regular column in the *Seattle Post Intelligencer*. She was an indefatigable letter writer and wrote regularly to her elected officials; for urgent issues, she sent telegrams. She hosted letter writing workshops at her home to teach this skill to others and to share the work load—an early form of social networking. Over her long career, Haig also built strong bonds with influential politicians who could further conservation causes, including Senators Warren G. Magnuson (Democrat, 1944–1981), Henry "Scoop" Jackson (Democrat, 1953–1983), Representative Thomas M. Pelly (Republican, First District, 1952-1971) and Dan Evans, variously state representative, governor and U.S. senator (Republican, 1983–1988).

Neither Emily Haig's nor Polly Dyer's efforts to preserve the Olympic Mountains ended with their participation on Governor Langlie's Olympic Park Review Committee. Both women were asked to join the Olympic Park Associates,

an organization Irving Clark had established to protect the park from further threats, and Dyer went on to become the group's president for thirty years, from 1957 to 1987. Olympic Park Associates under Polly Dyer's direction played an instrumental role in another logging controversy. Although national parks were established to protect important habitat, the Park Service was allowed to cut timber "in order to control the attacks of insects or disease," and to protect the public from trees in danger of falling—a process, still popular in places, known as "salvage logging." In the Olympic National Park, this loophole in the park legislation was enlarged to permit the cutting of many healthy trees.

Emily Haig. *Provided by University of Washington Special Collections (36207).*

In 1956, two summer park rangers, distressed by the extent of

salvage logging, contacted Polly Dyer and Phil Zalesky, who went to investigate. "Salvage logging," they realized, was mainly just a cover for getting as many big trees out of the park as possible before anyone noticed. In response, a group of conservation organizations—the Mountaineers, the Sierra Club, the Audubon Society and the Federation of Outdoor Clubs—banded together with Olympic Park Associates to report on the renegade practice. "Eventually we had a meeting with the Director of the National Park Service, Conrad Wirth," Dyer later recounted:

> *He said there would be no more salvage logging in the national parks—period. One of the things I do automatically, usually writing on my lap, is I took shorthand notes of what was being said. Pat Goldsworthy took my transcribed notes and sent them to the Director. Here is what you said. His response was, "Yes, I guess I did say it. I didn't know I was being recorded." But the policy changed.*

When the salvage logging was finally stopped in 1958, about 100 million board feet, by conservative estimate, had been taken from the Olympic Park and sent to the lumber mills.[45]

THE VALUES OF WILDERNESS

Beyond their efforts to save particular areas of Washington, both Polly Dyer and Emily Haig worked to preserve wilderness on a national scale. To the leadership of both the U.S. Forest Service and the U.S. National Park Service, wilderness—as defined by John Muir, Aldo Leopold and other wilderness advocates—was an obstacle to achieving their objectives as measured by either board feet of timber harvest or the number of visitors to a park. For preservationists at midcentury, the question remained, "How can we best delineate what is wilderness and how can it best be saved?" A definition was needed to draw lines on the map of Washington and other states of what should be protected from human settlement and exploitation. This need was a driving force behind one of the nation's most important environmental laws, the Wilderness Act of 1964, itself the culmination of decades of hard work.

In 1953, David Brower, Sierra Club executive director, and Howard "Zahnie" Zahniser, executive secretary at the Wilderness Society, realized that the best strategy was to unleash the power of grass-roots organizations to lobby for the protection of wilderness areas. To begin cultivating local wilderness advocates, Zahniser contacted John Osseward, Irving Clark and

Polly Dyer in Washington State as well as other activists around the country. Zahniser also corresponded with Emily Haig in preparation for drafting a suitable act. Her great interest in general wilderness protection shines through in an undated manuscript entitled "Why Do We Need Wilderness?"

> *The true worth of wilderness is difficult to put into words. We need places where we can be away from the crowds, where we can experience the delight of viewing outstanding examples of Nature's handiwork, where we can feel ourselves to be part of the natural world…We [also] need wilderness areas in order to study the relationship of living things to their environment—the science of ecology. We need a place in which to study and observe the life process as it has been carried on since the beginning of time, unaffected by man and his works…Then too, the idea of wilderness preservation is becoming increasingly important in the light of the recent rapid increase in the world's population. Man needs a few samples of Nature's greatest works—the wilderness—for his continued physical and spiritual being.[46]*

In 1957, Dyer was asked to testify for the wilderness bill at its first congressional hearing. Fortunately, she was so well prepared that she could take in stride the absence of a promised prepared statement.

> *Dave Brower met me back there [in D.C.] and got me a hotel room, which was not very fancy, in a very ancient hotel. Then, the fellows all stayed at the Cosmos Club that was a male club. So they bought all my meals. [Later] I walked up the stairs to where the Senate Building was. They were breaking for lunch. So Zahnie took me in hand and said you ought to say so and so. So we went to the Wilderness Society offices, which were up off of Dupont Circle. On the back of an envelope, I was writing all these notes in a taxi. I had been told that when I got back there would be a statement all ready for me. There was no statement. Just the back of the envelope…Later David Brower said, "Polly, do you mind if I edit your statement?" Which made it much easier. So I said OK. So that was my first experience before Congress. That was the Senate, then the House hearing.*

In 1959, Dyer organized a well-publicized twenty-two-mile coastal hike with Chief Justice William O. Douglas to protest a proposed coastal road to be built on Olympic National Park property. Seventy hikers walked for three days. The National Park Service believed the road was needed to support the tourism industry, which at that time consisted of a few motels and run-

down restaurants. On the hike, Zahniser heard Dyer describe the beach as "untrammeled," and in her stress on the word, he was impressed by "her sudden enthusiasm in describing that stretch of seacoast." Zahniser believed that this word, more than the "undisturbed" others had suggested, fit his purpose in drafting the wilderness legislation.

> *"Untrammeled"…provided a more flexible definition of wildness that would make possible the inclusion of lands that had been disturbed but might be healed if they were designated as wilderness. In addition, he preferred "untrammeled" because he also took it to mean "free, unbound, unhampered, unchecked," and so it implied that wild lands were "not subjected to human controls and manipulation that hamper the free play of natural forces."*[47]

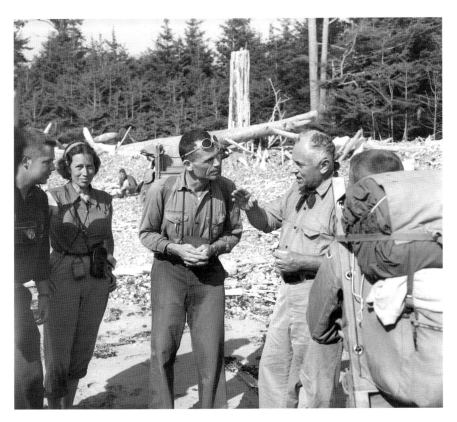

Polly Dyer (second from left) and William O. Douglas (center) protest the proposed coastal highway in Olympic National Park in 1958. *Museum of History and Industry (MOHAI) (PI 86.5.23791.1).*

The Wilderness Act of 1964, as written, would immediately designate as wilderness 9,140,000 acres of land already owned by the federal government. The act also would assign to Congress the exclusive power to designate additional wilderness areas and mandated a ten-year review process to identify and report to Congress potential wilderness areas. The bill—with Polly Dyer's "untrammeled" left untrammeled—sailed through the Senate and the House in the summer of 1964 with healthy margins, though Zahniser himself did not live to see the bill signed into law that September.[48]

POLLY DYER, EMILY HAIG AND THE NORTH CASCADES CAMPAIGN

Back in Washington State, another central conservation focus for Polly Dyer and Emily Haig was preservation of the North Cascades Mountains, the "American Alps," which encompass millions of acres of rock, ice and dense rain forest. Glacier Peak and surrounding valleys were the initial focus. After public hearings held around the state and intense lobbying by conservationists, a Glacier Peak Wilderness Area was eventually established under the 1964 Wilderness Act.

Even as conservationists worked to protect Glacier Peak, the movement for a larger wilderness area encompassing most of the North Cascades was gaining strength. In the fall of 1957, an organizational meeting for a proposed North Cascades Conservation Committee was held in Portland, Oregon. Attendees included veteran conservationists Emily Haig, Pat Goldsworthy and Phil Zalesky. Grant McConnell argued persuasively for a single-purpose organization, and that became the North Cascades Conservation Council (known as the N3C), in which Polly Dyer would rotate through various official positions.[49]

In the Sierra Club in 1958, when the discussion turned to hiring staff for the North Cascades campaign, someone suggested that Polly Dyer be the club's first Northwest representative. The initial response, from Leo Gallagher, a prominent member of the club, was "No, Polly's already doing that, so she doesn't have to be paid." It was quickly becoming obvious that being a woman was still a handicap. Dyer was subsequently interviewed for the position by at least two people who knew her well, as she later recounted:

> They'd been working with me for many years; they knew what I could do, what I had been doing. They asked me, well do you think you could administer? Do

you have administrative ability? Do you think you can use a Dictaphone?...
[A]fterwards...a close woman friend...said, "Well, you know, those guys are
just plain chauvinistic. They don't think women can do anything." And that's
basically what I think it amounted to, even though I'd been on the Board of
Directors of the Sierra Club, and Chairman of the Mountaineers Committee,
and all those other things...Up until then I hadn't thought about the woman
angle, but that may have had something to do with it because I don't think there
were any women representatives in the Sierra Club at that time...I shall never
forget it, because I was shocked to have those reactions from people I'd worked
closely with...I felt like I was at an inquisition.[50]

It would take more than a decade of hard work to establish the North Cascades National Park. The Forest Service fought the proposed park politically at all levels—local, state and federal—joined by a host of others, including the usual players of timber and mining industries and chambers of commerce and also new interests such as the Park Inholders Association (owners of private property within the national forest), outdoor recreation enthusiasts, hunters, skiers and anglers.

In 1961, at the urging of Grant McConnell and Polly Dyer, the Sierra Club hired a staff person to help in the campaign: Michael McCloskey, later the successor to David Brower as president of the Sierra Club. It was McCloskey who, in 1963, crafted the conservationists' ambitious park proposal for the North Cascades. This 130-page document delineated a huge area for the North Cascades Park—a total of 1.3 million acres.[51] Conservationists mounted a strong media campaign to bolster the North Cascades effort. The Mountaineers published *The North Cascades*, and the Sierra Club published *Wild Cascades: Our Forgotten Parkland*, both large-format picture books. David Brower made a supportive film, *Wilderness Alps of the Stehekin*, shown around the country. Polly Dyer reported showing the film at least one hundred times to groups in the state.

Now a tug of war for the control of the North Cascades began between the Forest Service and its allies on one side and the Park Service allied with conservationists on the other. The two federal agencies continued to fight each other with bureaucratic memoranda until President John F. Kennedy finally mandated the compromise often referred to as the "Treaty of the Potomac." It established a five-person committee to determine the management and administration of lands proposed for the new park and also asked Washington's governor to submit his own plan for the North Cascades. To develop his plan, Dan Evans appointed a sixteen-member committee, which

North Cascades National Park. *Ethan Welty.*

included Emily Haig and two other respected environmentalists, Jonathan Whetzel and William Halliday.[52]

The committee first convened on March 4, 1966. After much wrangling, the majority's final recommendation, over the objections of Whetzel and Haig, was for a park containing the Picketts (a range of vertical peaks) and a mishmash of wilderness areas already accepted for inclusion by all parties. It was the familiar mountain peaks of ice and snow with few trees. The total acreage was substantial, but the plan included little actual protection for lowland forests.[53]

By the end of 1966, after endless hearings and negotiations, the North Cascades Conservation Council realized that conservationists were unlikely to get all they wanted and a smaller park would be better than none at all. Reluctantly, they decided to support bills SB 1321 and HB 8970, settling for half of what had been proposed in 1963 as the national park.

The reality was that the nation was moving to the right politically and it could be years before a North Cascades National Park bill with any chance of success could be brought up again. Hearings on Senate Bill 1321 were held in April 1967, and House hearings were held in Washington State in the spring and summer of 1968. The number of park supporters stunned

Representative Wayne Aspinall of Colorado, always a foe of park bills. There were almost eight hundred requests to testify, most of them in support of the park and recommending amendments to improve protection. Both Emily Haig and Polly Dyer were instrumental in recruiting people to testify. The final episode in the drama was a bill swap between Senators Jackson and Aspinall. Jackson got the North Cascades National Park, and Aspinall got the Colorado River Water Study he wanted. President Lyndon Johnson signed the North Cascades Park Act on September 16, 1968.[54]

Polly Dyer had also been active on other fronts during this period. In 1958, she chaired the second Wilderness Conference sponsored by the Federation of Western Outdoor Clubs and went on to organize the biennial conferences until 1976. These conferences pulled together four to six hundred wilderness advocates from Alaska, Washington, Oregon, Idaho and California to discuss the contentious wilderness issues of the day. By 1976, Dyer had also become the outreach coordinator for the new University of Washington Institute of Environmental Studies. She used her formidable skills as an organizer and her extensive contacts throughout the Northwest to put the institute to the service of the wider community, bringing it out of the ivory tower of academia and into the rough-and-tumble world of the Pacific Northwest environmental movement. And in conjunction with Olympic Park Associates, she testified on an extension of the Olympic Park coastline to include a wilderness beach in the park's northwest corner.

INCREASING WILDERNESS

The 1964 Wilderness Act required the Forest Service to review its 34 million acres of roadless lands for additional areas that should be protected as wilderness. After major objections to its first report, known as RARE I (Roadless Area Review and Evaluation process), the Forest Service started a do-over called RARE II that recommended in 1979 only 269,000 of 2.5 million roadless acres be set aside as wilderness in Washington State national forests. To counter this analysis, the Washington Wilderness Coalition, with Polly Dyer on its advisory committee, was formed. The campaign gathered information on all Washington wilderness areas in order to submit an omnibus bill on wilderness protection to Congress. Karen Fant, mentored by Dyer, and Rick Gersten split the state between them, with Karen organizing eastern Washington and Rick, western Washington. As Fant described the action:

We felt it was essential that if we were going to have new wilderness designated in the state that there had to be a grassroots structure of groups around the state to create pressure and interest and educate the public in those congressional districts where the wilderness was…We were on the ground, we were going to meetings; we were helping people draw maps. We were on the phone with them constantly providing encouragement and support and enthusiasm.[55]

The Washington State Wilderness Act, passed by the U.S. Congress in 1984, designated nineteen new wilderness areas and expanded four other existing areas to protect one million acres of wilderness. It also contributed a new idea to wilderness protection that was adopted in the twenty other state wilderness bills. This was the "soft release" as opposed to the "hard release" favored by the Forest Service and timber companies. The latter meant that once an area was considered for wilderness, but not designated, it could not be considered again for protection and was open to logging. The "soft release" allowed wilderness areas not designated at first to be reconsidered in the next round of forest plans when new information might be available.

Dyer continued to protect wilderness on the board of Olympic Park Associates and North Cascades Conservation Council well into the second decade of the twenty-first century, as ever, a kind of permanent pinch hitter—one who often hit a home run. Emily Haig went on to serve as Seattle Audubon Conservation Chair until 1974. Following her death four years later, Seattle Audubon received a letter recounting a memory of Haig from 1944. The writer had been ten years old that summer, distressed by the death of his father, and whiling away the days on a vacant lot near his home. One afternoon, he wrote, "I…became aware of a well-dressed woman of middle years standing next to me in the tall weeds. In an interested tone, she asked me what I saw, and I tried to describe the intricate pattern of activity in the ant colony, to which she added a few of her own thoughts." She asked where he lived and then went on her way. A few days later, he received a package with "one of Fabre's books on the social insects, with the inscription, 'With every good wish, from Emily (Mrs. Neil) Haig.'" Years later he met her, at Seattle Audubon, and thanked her for the book. "She was obviously pleased, but I was a little disappointed that she did not so clearly recall that afternoon. Later…I understood that I was one of a vast number of young people who received timely and memorable encouragement from that very great lady."[56]

2

BUILDING COMMUNITY

ELDER STATESWOMEN

Joan Thomas, Hazel Wolf, Harriet Bullitt, Vim Wright, Estella Leopold—these five women have devoted their lives to protecting nature for everyone. Through twists and turns of fortune, despite setbacks and years of what seemed like tiny triumphs, they kept their eyes on larger goals. "They were good strategists, good tacticians," conservation scientist Dee Boersma has said. "What they also had in great measure was courage and persistence."[57]

Dates chronicling achievements cannot convey the years of struggle required to ensure the victories for Washington's environment portrayed in this book. The work was often slow, hard and far from glorious: standing on street corners to gather signatures, getting to know state and federal legislators, testifying at hearings and attending countless committee meetings. The glory is in the ancient forests, wetlands, parks and farmlands protected by laws that manage growth so that generations to come will still have a beautiful landscape and natural resources to appreciate, protect and nurture.

These five long-lived women are citizen-activists and professionals, citizen-scientists and university professors. They were all builders of community or, one might say, of many communities that began to coalesce as a single, strong, flexible and egalitarian community as the women and their work intersected and overlapped. They worked together on numerous campaigns, had great integrity and served as inspirations for many others within Washington and beyond. They represent the effort and dedication of hundreds of other

women who were not as well known or as long-lived but who have worked to make Washington one of the most livable places in the country.

The following profiles of these five women illustrate the diverse paths that led them to a passion for the environment and the contributions each has made to Washington State's environmental movement and to one another.

JOAN THOMAS (1931–2011)

When Joan Thomas arrived in Seattle as a young bride in 1955, she was astonished by the beauty of Puget Sound and the Cascade and Olympic Mountains. Those geographic bookends of the Pacific Northwest encompass the natural resources whose preservation would become her passion and her life's work for the next five decades. Born in Detroit in 1931, Joan and a cousin spent several summers during World War II in a cabin on Torch Lake in northern Michigan—a "wilderness" experience that may have influenced her future worldview: "We had no running water. We had no electricity. This was a pioneering experience for city girls." She attended a high school, she said, that "didn't have a college prep curriculum. It had shop for boys and it had commercial for girls, so I took typing and shorthand. And that came in handy" in her work in a series of secretarial positions.[58]

After the Korean War, Joan and her husband moved to Seattle, where their daughter was born in 1958. That same year, Joan went with a friend to a League of Women Voters meeting and was so impressed with members' analysis of issues that she joined. Within a few years, she had risen to the presidency of the Seattle chapter and served on the organization's state board, and she eventually became the youngest president of the Washington league (1967–69). Not only was the organization Joan's training ground in leadership, but it also whetted her interest in water quality and quantity, a subject to which she devoted many years of work, which included playing a key role in reforming Seattle's sewage treatment.[59]

In 1968, Joan was one of the original incorporators of the Washington Environmental Council (WEC). An early advocate of establishing an environmentalist presence and influence in the state capital, Olympia, Joan served as WEC's legislative vice-president in 1970 and helped shepherd one of the nation's toughest oil-spill bills through that year's special legislative session. Photos of Joan during this time show a petite young blonde woman with somewhat startling black-framed eyeglasses. Certainly not a physically

Joan Thomas. *Washington Environmental Council.*

imposing figure, her power came from other qualities frequently cited by her colleagues: her persistence and sharp mind.

Joan viewed the passage of the state Water Resources Act of 1971 as one of her greatest achievements. As WEC legislative vice-president, she led the effort to pass the bill, which expanded the definition of "beneficial" uses of water to include "in-stream" uses such as providing water (in the stream) for salmon. This seemingly minor revision revolutionized water policy in Washington: environmentalists could now argue that in-stream flows must be maintained for fish and other wildlife. The following year, Joan also helped negotiate passage of the Shoreline Management Act and the State Environmental Policy Act, two pillars of environmental law in Washington. In 1981, Joan was recruited to supervise the Water Quality Division of Washington's Department of Ecology. "The only [other] women in the agency were the director's confidential secretary and the librarian. I was the first woman in middle management and I was probably the first card-carrying environmentalist," she recalled. Three years later, she became the first woman to serve as a regional manager of the Department of Ecology, where she created a successful program to develop urban action teams for pollution control. She also had a passion for parks and, in 1997, was appointed to the Washington Parks and Recreation Commission. She also

served as a mentor to innumerable men and women, including Rod Brown, a later WEC president, who had this to say of the experience:

> *Of the people I first started working with, the two that stood out the most were Joan Thomas and Vim Wright…and it was clear to me…that these were women* [who] *when they said things, other people listened…* [F]*ortunately for me, they both were willing to take the time to mentor me…I would've been twenty-five or twenty-six years old and I probably didn't have a lot of wisdom at that point—not to say that I have it now but I have more than I had then—and I owe it to them.*[60]

Why did Joan devote her life to preserving Washington's natural resources? "I feel more and more that it's [about] future generations," she said. "I'd lived in a place that wasn't very beautiful, [and] I moved to a place that was very beautiful. I don't have grandchildren, but I have grandnieces and grandnephews, and I want it to be here for [them], for the water to be here."[61]

HAZEL WOLF (1898–2000)

By the time she died at 101, Hazel Wolf had become a symbol of the environmental movement in Washington State and the nation. Even though Hazel did not take up the conservation cause until she retired as a legal secretary in 1962 at age sixty-seven, her accomplishments as an environmental activist are legendary. As was her persona: Hazel was irreverent, smart and could be counted on for a zingy one-liner and a humorous story with a lesson attached.

She was born Hazel Anna Cummings Anderson on March 10, 1898, in Victoria, Canada, where her mother had moved after marriage to a Scottish immigrant. Upon her marriage, Hazel's mother lost her U.S. citizenship, as did her daughter, which would have a profound impact on Hazel later in life. Her father died when she was a child and her mother worked as a laundress, factory worker and sometime singer to support the family. Hazel grew up in a poor, multiethnic Victoria neighborhood on Vancouver Island.[62]

Hazel left school for work after the eighth grade because her family could not afford high school. But her stepfather paid for her to go to business school and found her a job with a law firm. Her typing was slow, her spelling indifferent and she knew nothing about the law or legal

Hazel Wolf. *MOHAI (2002.46.3367.1).*

terminology, but she was helped by the firm's law clerks. In 1918, she married and gave birth that same year to a daughter, but she and her husband soon drifted apart. She married Herb Wolf a decade later; she liked the name and kept it, but she was soon on her own again.

Along with many other Canadians fleeing economic depression, Hazel immigrated to the United States to find work. She lived mainly in Seattle and hoped to train as a nurse. When that proved impossible economically, she managed, in 1929, to land a job as a legal secretary. It was a role she would reprise throughout her life. As a secretary, she had considerable control over

the day-to-day functions of an organization, especially in the days when nonprofit groups rarely had paid staff. The secretary was always on an organization's executive committee but had relative freedom of action there. She had no illusions about the work, though: "It is common knowledge that, as secretaries, women in almost any enterprise do all the work. Men hold the top positions and get all the credit. The Audubon Society was run by men and the work was done by women."

At the age of thirty-three, Hazel returned to high school, attending night sessions at her daughter's school while working days. During the Great Depression, she was frequently unemployed, but with scholarship aid, she was able to attend the University of Washington, studying sociology with a minor in psychology. Standing in the cold at the welfare office waiting for her check, unable to find work, Hazel felt powerless in an economy ruled by the wealthy. She wanted to do something to help others as well as herself and so, in 1934, joined the Communist Party.

> *I joined because I could see that I had a personal interest in belonging to a group like that. I was in a bad way. Dependent on welfare, on their whims. Here was a group I could belong to that would fight for these things—comrades, rallying around and getting people to come and help. I had sense enough to know that you can't do anything much alone in the way of struggle against the establishment.*

The Communist Party was not yet labeled as a subversive organization; that didn't happen until after the Second World War, by which time Hazel had drifted away from the group. While a member, though, she learned a lot about organizing: "Organizing means getting people together collectively to carry out a task. I learned that if you want to get a job done, the first thing you do is decide whether it's a worthwhile job. Then you get help, and you don't waste any time. Organizing is instinctive with me, but through the party it became conscious."

While studying at university, Hazel got a job at the Civil Works Administration (CWA), a New Deal program, organizing community activities at a field house on Alki Point. Her job was to start up orchestras, crafts programs, basketball leagues—whatever would get people involved. Using the personal touch, knocking on every door, Hazel soon brought many volunteers to the community center. When the funds ran out and the center closed, Hazel moved on to the Federal Emergency Relief Administration. Her first project was to put unemployed teachers together with unemployed

adults for classes in the Adult Education Project. She organized the teachers and became secretary of the local group, which later joined the American Federation of Teachers. Fired for organizing, she went on to several other jobs before, in 1945, Hazel met John Caughlan, a civil rights attorney at the firm Caughlan & Hatten—or, as Hazel put it, "Coughin' & Hackin'"—and became the firm's legal secretary, a position she held until her retirement in 1962.

Hazel applied for U.S. citizenship in 1939 but was turned down because she was living with someone who was not her husband, and she was denied again in 1947 in the midst of the cold war's red scare. In 1959, the Immigration and Naturalization Service (INS) moved to deport her even though she had resident status as a legal alien. The deportation proceedings dragged on for four years, and her case went to the Supreme Court three times. When Canada refused to take Hazel back, claiming she was no longer a citizen, the INS tried to deport her to England, as her father had been British. Her case became a cause célèbre in Britain. A newspaper headline in London's *Daily Mail* shouted, "Seventh Bid to Deport Grandma." Finally, in 1963, an INS Hearings examiner dismissed Hazel's case. She was free at last.

In the late 1950s and early 1960s, Hazel returned to her early interest in nature, went on a camping trip around the country with friends and joined the Seattle Audubon Society. On a field trip to Lincoln Park in West Seattle, she had what has become a legendary encounter with a brown creeper:

> *Everybody was looking up at a Doug Fir. They handed me a pair of binoculars, and there was a bird, a little brown bird the same color as the tree, going up the trunk, pick-pick-pick as it went. When it got to the first bough, it would dive down to the bottom of the next tree and go up and up and up, eating and eating—something I could not see, it was so small—and then again to the bottom of another tree. I was told this was a brown creeper and that it always went up the tree, never down, and that it made its nest under pieces of loose bark on the tree trunks. I saw the little brown creeper, and I knew that bird. It worked hard for a living, and so did I. It had a lifestyle, always up the tree, just like I had a lifestyle—get up in the morning, eat breakfast, catch a bus and go work, eat lunch, go back to work, come home at night. I related to that bird.*

Hazel seemed to resemble the diminutive brown creeper. She was of slight stature. Her bright eyes sparkled. She was incredibly observant and hardworking. Her only disguise was her halo of curly white hair.

When Hazel attended a Seattle Audubon Society membership meeting in 1962, she found the group arguing about its bylaws and constitution.

With her background as a legal secretary and a founder of multiple unions, Hazel offered to redraft them, which she then presented to the president of the board. He invited her to attend a board meeting, and there she volunteered to head the committee on office supplies. Soon she had joined various committees, become office manager and organized the volunteer staff. She would later say, "Now I have been given a lot of recognition and awards for my work in the environmental movement, but it all comes down to the organizing skills I learned in the thirties—that is getting everyone involved—and the office skills I practiced as a legal secretary. Nothing glamorous about it, but we put Seattle Audubon on the map."

The society asked her to join the board of directors, and soon she became secretary, a position in which she remained for more than thirty years, until 1997. With retirement from Caughlan & Hatten, she became a one-woman whirlwind of activity, and the Audubon Society was the beneficiary. Like John Muir, she believed we are all part of the natural world; by saving nature, we save ourselves.

At Audubon, she found herself in a community of strong, effective and dedicated women. At her first Seattle Audubon Society membership meeting, she was particularly impressed by Emily Haig, chair of the Conservation Committee. A partnership was born. Hazel rented an apartment in Haig's house for ten years, and Haig became a mentor to Hazel. She taught Hazel how to lobby, write testimony and negotiate the politics of the Washington environmental community.

In her forty years with Audubon, Hazel helped to found some twenty of the twenty-six Audubon chapters in Washington State and one in British Columbia. She also served as secretary of the Olympic Park Associates and the North Cascades Conservation Council; as president of the Federation of Western Outdoor Clubs (in 1977); and then, until her death, as editor of the organization's newsletter, *Outdoor West*. As her reputation spread, Hazel used her star quality and organizing skills to reach beyond the environmental community. She became known for her ability to start organizations and establish coalitions between traditionally white middle-class environmentalists and Native Americans, labor unions and people of color.

In 1978, Hazel led a major campaign to unite Northwest Native American tribes and environmentalists in their common concerns. Traveling with Bernice de Lorne, she visited twenty-six tribal leaders across the state. At each stop, Hazel and Bernice held meetings on environmental issues where Hazel convinced people to come to a joint meeting of tribes and environmentalists the following summer in Spokane. Since then, environmental organizations and

Native American tribes have collaborated on a number of issues, including forest preservation, nuclear waste cleanup at Hanford and protection of the Columbia River. Later, Hazel worked with Seattle residents to set up the Coalition for Community Justice to tackle environmental justice issues poor people and people of color faced.

Hazel was to many an inspiration. "I think of trees now as a cathedral," remembers Maria Cantwell, who became Washington's second female senator in 2000. "[T]hat probably first got influenced by Hazel [she] talked about these as a spiritual place…I just got a sense of that passion that filled her and kept her going, and she kept it going.[63]

HARRIET BULLITT (BORN 1924)

When you visit Sleeping Lady near Leavenworth, Washington, you may see a small, seemingly ethereal figure walking along the path from the Kingfisher dining room, her silver hair glowing as she passes a Chihuly crystal sculpture. When she draws near, you realize it is Harriet Bullitt, still beautiful in her mid-eighties, dressed in a plaid shirt, jeans and hiking boots and probably heading to O'Grady's Pantry to visit with friends. The food there is excellent, the coffee great and the atmosphere peaceful.

Sleeping Lady is a mountain resort and conference center Harriet created. It's home for Harriet, and a home away from home for her guests. Her values and love of nature are revealed in buildings that are rustic on the outside with ecologically sensitive comfort on the inside, set in grounds that replicate the native forest. Asked about her, Jeff Parsons, who has worked with Harriet for decades, illustrates her philosophy with one of her favorite images, the parable of the long spoons

> *There are two banquet rooms filled with people* [seated at tables laden with food, with only long spoons to eat with]. *In one, the people are starving and suffering* [because they can't manipulate the spoons to feed themselves]. *In the other the people are contented and happy* [because they] *are feeding each other with the long spoons, they are helping each other instead of themselves and everyone thrives.*[64]

Harriet Overton Bullitt is a scion of the Stimson family, descendants of T.D. Stimson, who moved his timber operations, along with his sons, from

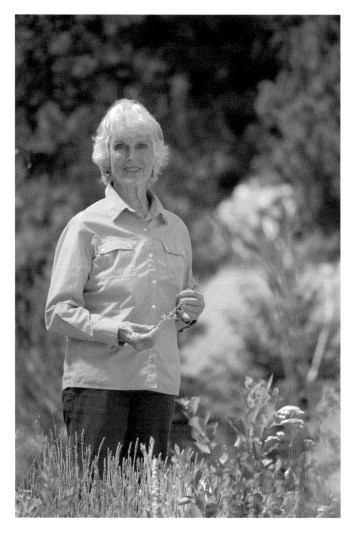

Harriet Bullitt. *Jeri Vaughan.*

Michigan to the Pacific Northwest in 1889. One of his sons, C.D. Stimson, founded the Stimson Lumber Mill in Ballard, made a fortune selling timber during the Klondike gold rush and presciently invested in Seattle real estate, leaving a fortune that his descendants then built upon.[65]

Harriet Bullitt, born in 1924, grew up in circumstances radically different from those of Hazel Wolf, in the exclusive Highlands neighborhood just north of Seattle. She remembers a carefree youth at the Highlands and an early interest in nature with summers spent on her family's three hundred

acres in Icicle Canyon near Leavenworth. Harriet at first settled on a career in chemical engineering, an unusual choice for a woman at the time, but quickly ran into a hostile dean at the University of Washington who forbade her to use the engineering library lest she distract serious men students. Harriet transferred to Bennington College in Vermont to try "my hand at what girls do," married and moved to Florida.

In her words, her story continues: "Florida set the stage; I was there from 1957 to 1963 and I took up scuba diving. We went to the Episcopal Church as much from custom as anything else. One evening at the Christmas service, I saw the minister turn away a black couple at the door. I never went back. I decided to turn to nature worship. Why not? Underwater limestone caves were just like a cathedral."[66]

In 1963, Harriet, by then divorced, returned to Seattle and went back to school at the University of Washington, where she ultimately earned a degree in zoology. Given the Northwest's extraordinary natural diversity, she feared that many Washingtonians—especially the growing flood of newcomers—did not have an "educated conscience" about nature. So she decided to start a publication dedicated to the natural history of the Pacific Northwest. *Pacific Search—A Journal of Natural Science in the Pacific Northwest* was launched in 1966 to cover the "full range of the local science scene." It was "written for everyone who smells seawater, moist forests and mountain air and who wants to look below the surface to find out more." Readership rose to seventy thousand in its twenty-five-year run.

Harriet and the Bullitt family have had their most profound impact on the Northwest's environmental community through the Bullitt Foundation, founded by Harriet's mother in 1952. In 1991, the family sold their media empire (King Broadcasting) and established a $100 million endowment for the foundation. Three years later, Denis Hayes, national coordinator of the first Earth Day, was hired as president. Soon after, board membership was extended beyond the family, and the foundation began to focus on protecting and restoring the environment of the Pacific Northwest and quickly became the source of funding to move the environmental community into a more professional phase, hiring staff rather than relying entirely on volunteers, setting up offices and buying computers, all of which required investment.

Harriet managed the foundation for over twenty years as chair of the executive committee. Spurred by her vision and strategy, it grew from a small family foundation to become a powerful force in conservation, willing to take risks; funding small and new groups, encouraging them to become self-sufficient; and tackling important issues.

By the early 1990s, Harriet was living permanently at the old family vacation home, Copper Notch. Still drawn to nature, perhaps more so than ever, she became involved in local environmental efforts. When a 670-acre church camp went on the market, she bought it, restored the native vegetation, transformed the cabins into unpretentiously luxurious vacation homes built with recycled materials and, in 1995, opened Sleeping Lady as a resort and conference center. In Harriet's words:

> [Its] *mission is to set up a place that attracts people to do their creative work. The design is to have Sleeping Lady as a backdrop for those that are achieving in their world, as an inspiration from whatever natural value, to treat them well when doing hard work—lawyers, environmentalists… People deserve better than bad food and bad beds. Environmentalists must get rid of their hair shirts, doing everything on the cheap…They should be pampered and honored.*

In 2000, Harriet joined the National Audubon Society board ("I gave them funds for the forest campaign so I would be listened to," she noted in an interview), and Sleeping Lady subsequently became a favored gathering place for Audubon meetings. She has actively participated in many Northwest environmental battles, but the issue she keeps returning to is the restoration of Icicle Creek and its wild salmon runs. Harriet fought for nearly fifty years to have the U.S. government remove diversion dams that blocked the main channel next to her family's property. She eventually funded the job herself, and free-flowing water is back in the Icicle (at least when the state's hatchery management doesn't block it). Native fish—but not wild salmon yet—are back in the once-blocked channel.[67]

At the 2004 gala event at which Harriet was the recipient of the Audubon Medal for her lifetime body of work to conserve nature and birds, Denis Hayes commented that she had taught him the "Darwinian value of optimism":

> *It was early in her relentless battle to get the fish obstructions out of Icicle Creek. The U.S. Fish and Wildlife Service had once again just double-crossed her by abrogating the agreement to remove three dams by only removing one. However, she was already plotting her next move on the political chessboard, and I asked her how she managed to maintain her enthusiasm. She just replied offhandedly, "Because we're going to win." And she paused for a bit, and then went on… "You know, when*

there are two people, and one of them really believes that she's going to win, and the other one fears that he's going to fail, generally they're both right.[68]

VIM WRIGHT (1926–2003)

One of the things that we all think about, about Vim, is that wonderful name, Vim. For many of us Vim is vigor and value. Vim came with so many values. I realized she gave me a life in a way that I would have never had without Vim. Vim was a connector of all of our lives…Up until the last day of her life she was still connecting people to go on and do things.

One of the problems is Vim's life was much too short and it was much too short for Vim. John Burroughs said, "I still find each day too short for all the thoughts I want to think, for all the walks I want to take, all the books I want to read, and all the friends I want to see. The longer I live, the more my mind swells from the beauty and the wonders of the world." And that was certainly Vim's philosophy up until the very end. This was a woman that fought to maintain this life because she was so in love with all of the things that she was doing and was going to do that and now we all are going to continue.[69]

So began the memorial service for Vim Wright in Seattle's Discovery Park as Dee Boersma eulogized her dear friend and ally who died of lung cancer just three days shy of her seventy-seventh birthday.

Born Lizetta Iacovidis on June 4, 1926, in Istanbul, Turkey, Vim was adopted by an American military couple, General John Crane and his wife, Mary, who named her Violet Crane. She gained the nickname Vim on the school basketball court after the family moved to Baltimore, Maryland, in 1938. In the 1940s, Vim married Edward John Wright Jr.; after their divorce, Vim moved in 1960 with their two sons to Denver, where her environmental efforts began.

Throughout her life, Vim Wright was in the "construction" business. She built bridges between disparate individuals and communities. She founded and built organizations. She built a support system for women leaders in Washington State. In large degree, the Washington environmental community is a house that Vim built.

Vim's appearance was often casual and her approach warm and straightforward. Photos of her in her twenties and thirties show a striking, dark-haired beauty. Intelligent and astute, Vim would size up a person or

Vim Wright. *Provided by Estella Leopold.*

a situation almost instantly—usually correctly. When she was old enough to vote, Vim registered as a Republican. Later, after she moved to Seattle, she had to explain to nonplussed colleagues how she, a great environmental activist, could be a member of the now very un-green GOP:

> *I am a card-carrying Teddy Roosevelt Republican. I don't believe in partisan politics. I believe that the environment and conservation are not partisan issues. It's like health care. It shouldn't be a partisan issue. It belongs in the same breath* [as] *protecting our country. I call myself a Republican because I did work as a Republican and organized for the Republicans in Maryland. Most of the Republicans in Maryland were black. People who ran for office and* [won] *were Democrats and as conservative as you could get,* [so] *I joined the Republicans.*[70]

Vim's love of nature began early, with both her biological and adopted fathers sharing with her their love of birds.

> *I remember the first bird I really saw was a nuthatch in my yard* [in Denver]. *I made* [in needlepoint] *a pillow with all the birds in* [my]

yard. I decided to take an ornithology course so I could learn about birds and be a bird watcher. I joined the Audubon Society…One day, on a hike in the mountains above Denver, [my friend] *and I looked down into the city. There was a beautiful shimmering cloud, a pink cloud. Leah said, "Vim, that is pollution." And I thought, "My children are under that!"*

That conversation ignited a lifelong resolve:

I realized that I could not do enough for my children and those of my friends. What I had to do was work to make the world better. I don't mean in political terms. I mean in health terms. The only way I can protect those I care about is leaving a healthier world. I started getting involved with issues and started broadening my thinking. Since I liked wildlife, I talked about water pollution and the Clean Water Act, air pollution and the Clean Air Act. I found that every time I talked about wildlife and the land it really got to me. That is how I got involved: it was mostly working with the Audubon Society.

Vim's first major foray into environmental issues came when she joined the fight led by Betty Willard and Estella Leopold in 1970 to preserve the Florissant Fossil Beds near Manitou, Colorado, from real estate developers. Estella remembered when Vim entered the picture, the beginning of a lasting partnership:

[I] first met Vim Wright when some of us on the Colorado Open Space Council were in federal court in Denver trying to save the Fossil Bed…The bulldozers were parked on the edge of the property and we were in danger of losing the case before Congress could pass [a] *bill to make the area into a national monument.*

I got this call from an unknown person, a Mrs. Wright. And Mrs. Wright said, "I read about these cases in the paper. What are you going to do in court tomorrow in case you lose?" And I said, "I don't know. What should I do?" And she said, "Well, I was thinking of taking some friends of mine down there to lie in front of the bulldozers. How would that do?" I consulted with my colleague and he said, "Woo, ha, umm…Tell her that's OK but not to mention the Colorado Open Space Council." So the next day, Vim got herself all dolled up, got her hair done, gathered her friends around—pregnant women and women with children—and they went on down to Colorado Springs and did just that. At the very last minute, the

courts cooperated, and she was off the hook. Later on she said, "You know, it was a pretty safe bet because no man is going to run over women in high heels and pearl necklaces."[71]

While she was working to protect the Florissant Fossil Beds in the 1970s, Vim was made president of the Denver Audubon Society and joined fights to stop a proposed dam project and the poisoning of wolves and coyotes. After seventeen years in Colorado, in 1977, Vim received a letter inviting her to apply for the assistant director's position at the University of Washington (UW) Institute for Environmental Studies in Seattle—an offer made sweeter by the fact that Vim's friend from Save the Florissant days, Estella Leopold, had moved to UW a few years earlier. Vim brought passion, creativity and a love of joint action to the assistant director's job. She came on at the institute as a full professor without coming up the ladder, without having gone to college. She taught, served as an administrator and worked with officers in the U.S. Geological Survey, Bureau of Land Management, Fish and Wildlife Service and other agencies. Her strategy, she said, was to make the institute an asset to the community, a resource to help address the pressing questions of the day. Her institute philosophy she described this way:

What I can do is bring people together who can help each other. That is very exciting. [The] environmental community many times has the conceit to think they know the answers. I look at it differently. I think we should be aware enough to know what questions to ask and then find the people to provide us with answers. I don't know the answers, but I sure know the questions.

Vim was active in the environmental community outside the university as well. She served on the board of the Washington Environmental Council in the 1980s and 1990s and on the stewardship board of Audubon Washington, helped found four organizations and volunteered in many initiative campaigns. In the early 1990s, Vim and Estella Leopold started an informal support group for female leaders in 1992. They named it GOWNS (Good Old Women's Networking Society).[72] At Vim's memorial service, Christine Gregoire recounted how inspiring Vim had once been to her personally:

In one of my downest periods while serving as director of the Department of Ecology, I thought about it long and hard, and then I called Vim one day. I said, "For the agency and for its fairness, I have decided that I will step down as the head of the department." She said, "OK, why?" So I

started giving her my reasons for it, and she said, "OK, you can stop now."
I, of course, thought that I had convinced her of my reasoning. But she
immediately said, "You will not be doing that [quitting]. This is what
you will be doing…You haven't been doing a good enough job on this, and I
expect some improvement. And, oh, by the way, what have you done on this
other stuff?" The next day, I got up and went right back out, and I have
forever remembered that moment with Vim of inspiration and her telling me
what to do. Every time I saw her I [thought] about that. She made me
tougher. She made me stronger. She made me recommit to what's right for the
citizens of the state of Washington.[73]

In 1995, Vim was appointed to the Washington Conservation Commission, an independent state agency that works with local conservation districts to encourage landowners to voluntarily take advantage of various incentives for land conservation. Jackie Reed, a rancher from eastern Washington, characterized her efforts this way: "It is fascinating how Vim works with ranchers. She keeps the communication lines open. She spends a lot of time cultivating relationships. She picks up on issues, offers advice and finds someone who can help them. She doesn't just listen and walk away."[74]

Vim agreed:

That comes from organizing and networking. When I first got to be chair,
I wanted the Conservation Districts to be able to talk to us…We wanted
open communication…I sat down and telephoned all the chairs of the
districts. They had never been contacted before. They were delighted to talk.
I was delighted because I learned so much, especially [through] personal
relationships. It really helps with the work. Knowing names, voices, and
faces—and keeping avenues open.

Vim had a deeper reason as well for linking farmers and environmentalists, she said: "The last stand of endangered species is on private lands. Most of these private lands are owned by [people in] agriculture. That's my hidden agenda. A lot of those lands are beaten up. They have to be cared for. These are good for wildlife. They are not under concrete. If properly treated, the ranchers and wheat-grower farmers can make a living in the third, fourth, and fifth generations."

In 2001, Peter Goldmark, Bob Rose and Vim Wright launched Farming and the Environment, a nonprofit organization dedicated to protecting both the economic vitality of farming in Washington State and to promoting the

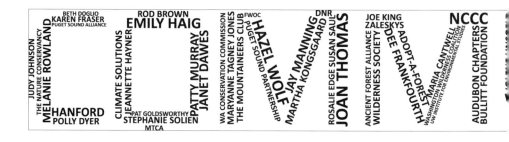

environmental stewardship of the state's agricultural landscape. Throughout her life, Vim worked to perfect her ability to find common ground on divisive issues, and she considered Farming and the Environment one of her most important achievements.

ESTELLA BERGERE LEOPOLD (BORN 1927)

Vim Wright's longtime associate Estella Leopold is a world-renowned paleobotanist, gifted teacher, member of the National Academy of Sciences and conservation activist with many victories to her credit. Born in 1927, she is the fifth child of Estella Bergere Leopold of Santa Fe Hispanic heritage and Aldo Leopold of Iowa German heritage. Her father, on everyone's list of great conservationists of the twentieth century, was a forester, a founder of the Wilderness Society, a philosopher of the land, a professor at the University of Wisconsin–Madison and the author of *A Sand County Almanac*, with its famous concluding essay, "A Land Ethic."

In 1935, when Estella was eight, the Leopolds purchased a run-down Wisconsin farm with a chicken coop that had seen better days. Here was Aldo Leopold's opportunity to demonstrate his land ethic as well as a methodology for restoring the land. The chicken coop was quickly dubbed the "Shack," and the huge job of the property's restoration became a family affair. Of the experience, Estella later said:

> Well, we just loved being in the country. It was fun being around the city, but we really had fun when we went to the Shack...We learned all our plants and animals and Dad would take us out on walks and say, "Now, here's some sign, what do you see here on this footprint? What game was that? And here is a mark in the snow. Who was hunting? What was happening here?" [Using] owl marks and the grouse track, and so forth.

Community Graphic.
Adam Kuglin.

And so we learned a lot about reading the landscape with Dad on these
walks, and we were forced to learn all the plants, because Dad always said,
"Well, what was in bloom today?"

In 1948, Estella went to the University of Wisconsin to study botany, then to the University of California and finally to a Yale PhD program in plant science. For her PhD thesis, Estella analyzed pollen from soil core samples taken in Connecticut. By identifying the pollen in soil layers, Estella was able to construct a history of vegetation changes over the last thirteen thousand years, after the glaciers retreated from the Hartford area. In 1955, the U.S. Geological Survey (USGS) in Denver hired Estella as a research botanist. Here she did her pioneering work on fossil pollen and vegetation change in preglacial formations dating from as far back as sixty million years ago.

Estella entered the fray of conservation activism with her 1963 testimony in support of the 1964 Wilderness Act. Amy Roosevelt, Eleanor Roosevelt's niece, convinced Estella that as Aldo Leopold's daughter, her testimony for the act would carry weight. In 1964, Estella co-founded the Colorado Open Space Council, a highly effective umbrella group of ten to fourteen outdoor clubs. One of Estella's more important conservation successes was protecting the Florissant Fossil Beds, one of the richest fossil beds in the world, often described as the Rosetta Stone of paleontology. Fellow scientist Betty Willard and, as we've seen, activist Vim Wright joined in the fight to save the site from real estate development and have it declared a national monument. Estella decided to fight the developer in the courts, seeking a restraining order to stop the bulldozers while legislation to authorize the area's protection made its way through Congress. In addition, she and Betty mounted a vigorous public relations campaign, lobbied members of Congress and formed an advocacy organization, Defenders of the Florissant. Legislation was finally passed, and in 1969, the Florissant Fossil Beds became a national monument.

In the early 1970s, the University of Washington invited her to be director of its Quaternary Center.[75] After five years there, she stepped down as director

and began teaching in the university's School of Forestry. Estella's magic as a teacher is compelling, as Lynn Bayrich of the Washington Conservation Commission has pointed out:

I think Estella is more of a visionary, and [there are] two things that make her quite different, I think, probably, from Vim [Wright] or from Joan [Thomas]. She's a scientist; she's a botanist. And so she's really focused a lot of attention on pollen, ancient pollen, and looking at the way the world used to be…She sees through what's there, and she tells you what used to be there, and what were the bones underneath… and how it's played out over time…I think because she does have that

Estella Leopold. *Provided by Estella Leopold.*

historic kind of X-ray vision, she also can project that forward and see
where we're likely to go and what needs to happen if we want to avoid
disaster and head in a more positive direction. So her visionary quality
is informed by her scientific understanding.[76]

After the eruption of Mount St. Helens in 1980, Estella, along with other scientists, urged Congress to stop the Bureau of Land Management from "restoring" the area with nonnative plants and instead to leave the land alone. The result was a national monument, a place where scientists had access to a natural laboratory to study landscape recovery.[77] Between 1982 and 1987, Estella was appointed by a succession of Washington State governors to advise on plans to store high-level nuclear waste at the Hanford Nuclear Reservation, by the Columbia River. She and her scientific colleagues were able to demonstrate that, because of its geology, the site was not suitable for the storage of dangerous nuclear waste.[78] Always generous with her time, especially with students and to foster conservation, Estella has carried on the Farming and Environment program begun in 2001 by Vim Wright, Peter Goldmark and Bob Rose to build trust between the farming community and environmentalists. In July 2010, Estella was awarded the internationally prestigious Cosmos Prize for her scientific accomplishments and her lifelong efforts to support conservation and foster the land ethic. Now in her eighties, she continues to hike, do research and gather people together for wine and cheese at her house to support important causes and conservation-minded politicians. During an interview at the Shack in Baraboo, Wisconsin, in 2003, Estella responded to a question of what thoughts she would pass on to the next generation. She responded with a comment that might just as well have been voiced by Joan Thomas, Hazel Wolf, Harriet Bullitt or Vim Wright: "I would like to suggest one of Dad's adages, 'Do the right thing!' Ecologically, politically or whatever."[79]

SAVING ANCIENT FORESTS

BONNIE PHILLIPS, MELANIE ROWLAND AND HELEN ENGLE

Bonnie Phillips has been called an eco-Nazi. Twice, logging trucks in the Mount Baker–Snoqualmie National Forest northeast of Seattle have run her off the road. She shrugs. Washington and Oregon are where the big wave of U.S. logging ran out of room, and the timber wars there—between loggers and environmentalists over uncut remnants of ancient Douglas fir and hemlock forests—were not beanbag fights. Such was how *Time Magazine* introduced Bonnie Phillips as a recipient of the Hero of the Planet Award (sponsored by the Ford Motor Company) in 1998.[80] She was—and still is—a fierce forest activist in Washington State. She dates her love of trees to her childhood: "I was brought up in southern Wisconsin, [in] a small town south of Milwaukee. One of the hallmarks of that little town was, about a third of the town was park…[M]y home was about a block away from the beginning of the park, and…it went all the way down to Lake Michigan. There were some great big wonderful old trees there so I got attached to trees at a very early age."[81]

Bonnie had her first taste of the Northwest when she moved to Washington in the mid-1960s with her first husband. She went back to school in Wisconsin after her divorce, but in 1970, after a stint in a Vermont commune, she moved back to Washington permanently. At the University of Washington, she took a climbing class and went on to marry her instructor. She did a lot of hiking, climbing, skiing and running—until severe injuries developed into fibromyalgia and she had to spend much of her time in a wheelchair. In 1987, Bonnie succeeded her husband as president of Pilchuck Audubon

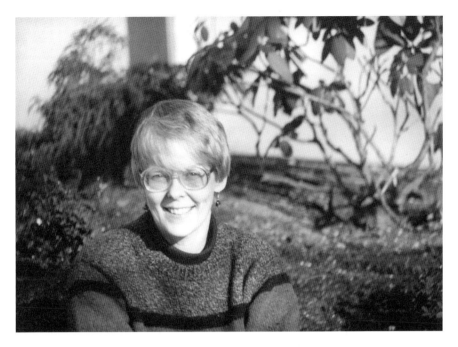

Bonnie Phillips is a leader of the Adopt-a-Forest program. *Provided by Bonnie Phillips.*

Society, the local chapter. "At that time, the whole forest issue was coming to the forefront," she remarked, and indeed it was. The Mount Baker–Snoqualmie National Forest was in the Audubon chapter's purview, and Bonnie Phillips gradually became a central figure in the fight for Washington's ancient forests, in journalist William Dietrich's words, "a quintessential example of the citizen activist who has bit into the vulnerable heel of the timber industry and, like some determined terrier, won't be shaken off."[82]

SAVING ANCIENT FORESTS REVISITED

Why, after decades of (often successful) national wilderness conservation action, was a renewed effort in environmentalism needed in the late 1980s? After some of Washington's ancient forests had been incorporated into the U.S. National Park system and the wilderness system created by the Wilderness Act of 1964 and the 1984 state wilderness acts,

Senator Mark Hatfield, the powerful senior senator from Oregon, had called a halt. There would be no future legislation to protect ancient forests, he said, and the Washington congressional delegation agreed. The remaining trees, ancient or not, that were in the federal government's jurisdiction and not covered by these acts were to be open to cutting by timber companies.[83]

With the prospect of congressional help thus blocked, it was now up to the citizens of the Pacific Northwest to save the remaining ancient forests in the federal courts and on the ground. Washingtonians and their allies were ready. The thirty-year struggle for wilderness and old growth had built a strong and resilient environmental movement. The *American Lawyer* magazine would call the legal cases that came out of this renewed battle to protect Pacific Northwest forests "the most important public lands management litigation in this country's history."[84]

Washington women made up the bulk of the volunteer army joining in to save ancient forests once again. Notable among these for their leadership roles, in addition to Bonnie Phillips, were women like attorney Melanie Rowland, a new volunteer to the Seattle Audubon Conservation Committee, who became a key figure in three Ninth Circuit lawsuits; Jean Durning, regional director of the Wilderness Society in Seattle; and Helen Engle, then on the National Audubon Society Board.

Until the mid-1970s, old-growth forests were considered "biological deserts" by most foresters and the prestigious University of Washington School of Forestry because they contained few game species: if you couldn't fish, hunt or trap it, it didn't count. However, many scientists, conservationists, birders and hikers rightly saw these ancient forests as a rich and diverse assemblage of plants and animals, all interdependent.

The 1976 National Forest Management Act (NFMA) upset the view long-held by foresters by incorporating in its provisions a keystone of the new science of ecology: that all parts of an ecosystem—birds, plants, insects, human beings and so on—are intertwined and valuable to its functioning. Eliminating one part of an ecosystem—for example, predators—undermined the viability of the whole. The NFMA imposed a "viability" standard in managing forestland, which George Hoberg of the University of British Columbia's faculty of Forestry called a "fundamental transformation of forest policy." The NFMA, he pointed out, requires that forest planning "provide for diversity of plant and animal communities based on the suitability and capability of the specific land area in order to meet overall multiple-use objectives." The implementing regulations of the new law then transformed this general

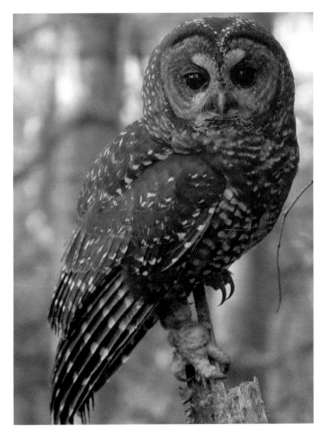

The northern spotted owl. *U.S. Fish and Wildlife Service (USFWS) Pacific Region.*

guideline into a stringent requirement: "Fish and wildlife habitat shall be managed to maintain viable populations of existing native and desired non-native vertebrate species in the planning area."[85]

In the late 1980s, the U.S. Forest Service was preparing to release a draft plan for national forests in Region 6—Washington and Oregon. As required by the new law, the Forest Service named an "indicator species": the northern spotted owl. The northern spotted owl is a bird of medium size (up to eighteen inches in length) with brown feathers spotted with white. Highly territorial, with a large home range in impenetrable old-growth forests and a very low birth rate, little was known of the species until the 1970s, by which time its numbers had already begun to decline, along with its habitat. The health of this indicator species over time would be used to measure the

success or failure of the Forest Service's management of the forest, as well as to test for "viability" of national forest ecosystems in the region.[86] This finally gave environmentalists a set of U.S. Forest Service decisions about old-growth habitat to challenge in court.

THE U.S. FOREST MISINFORMATION SERVICE

The exact amount of old-growth timber in Washington and Oregon national forests was shrouded in bureaucratic mystery. The U.S. Forest Service provided many estimates, all of which tended to be wildly overblown, so as to allow continued logging. The agency was, in effect, cooking the books: they estimated twice as much old growth as actually existed by including second-growth forest, forest fragments, alpine fir and other noncommercial species that could not meet the standard, as defined in 1986 by the Old-Growth Definition Task Group. When Wilderness Society biologist Peter Morrison mapped old-growth using GIS mapping data in 1987, he found only 2.4 million acres of true old growth where the forest plans had reported more than twice as much.[87]

Forest Service misinformation relied for its credibility on public perception that the service was above reproach. This perception was married to the Forest Service belief that no matter the facts, foresters were always right. This complex belief system began to crumble when scientists and conservationists could not verify service estimates with ground surveys. In light of this situation, National Audubon Society's vice-president Brock Evans suggested that the best strategy for saving the last ancient temperate forests in the Pacific Northwest, and in the nation, would be to target for preservation special places identified by local activists, not the forests in aggregate. Forest advocates then could talk to their senators and congressional representatives about certain forests and why they should not be cut.[88]

BONNIE PHILLIPS AND THE ADOPT-A-FOREST PROGRAM

In early 1987, the National Audubon Society decided to map the Northwest forests using volunteers from the twenty-four Audubon chapters in

Washington State—and others in Oregon and California—to come up with its own documented analysis of the extent of old-growth forests in the region. The results of the Adopt-a-Forest Program, as the survey was called, would then serve as the foundation for what came to be called the Western Ancient Forest Campaign and its efforts to protest timber permits. The mapping program built on the successful campaign for the 1984 Washington Wilderness Act led by Karen Fant and Rick Gersten (see Chapter 1). In Washington, there were two state coordinators. One included Okanagon-Wenatchee, Colville and Umatilla National Forests on the drier east side of the Cascade Mountains, terrain not suitable habitat for the spotted owl but home to other old-growth species such as the northern goshawk and the pileated woodpecker. Bonnie Phillips was the coordinator for the western side, which took in Mount Baker–Snoqualmie, Olympic and Gifford Pinchot forests. West of the Cascades, the remaining forests were dense and luxurious, with ideal growing conditions for Douglas fir, hemlock and western red cedar—and habitat for northern spotted owls. The two coordinators were responsible for hiring mappers, for a small stipend, from the local chapter if they could. (To help defray costs, Audubon had available $1 million for the campaign over a couple of years.) The mapping began in early 1988 with a dual purpose of "ground-truthing" Forest Service maps and developing Audubon's own forest inventories. For each national forest, at least one activist served as point person—and as it turned out, eleven of those twelve were women.

On the western side, to map Olympic National Forest, Alexandra (Alex) Bradley, co-founder of the Quilcene Ancient Forest Coalition and later founder of the Olympic Forest Coalition, was joined by Ann and Nigel Blakely (both biologists) of the Black Hills Audubon Society, and for Gifford Pinchot National Forest, Susan Saul was the lead activist. On the eastern side, Liz Tanke of the Sierra Club, Sue Hoover of the North Central Audubon Society and Pat Rasmussen of Leavenworth kept watch over Okanagon-Wenatchee National Forest. Suzanne Hempleman of the Spokane Audubon Society was the key activist on Colville National Forest, working closely with the Inland Empire Public Lands Council (now the Lands Council), the major forest group on the Colville. And for Umatilla National Forest, Shirley Muse of the Blue Mountain Audubon Society in Walla Walla worked extensively on monitoring and challenging timber sales.[89] Oregon writer Kathy Durbin described the hard work mapping entailed:

Volunteers in the Audubon forest mapping project ventured into remote draws and rugged canyons, often on foot or horseback, to look for pockets

of old-growth ponderosa pine, western larch, and, on wetter sites, Douglas fir and white fir. They used aerial photos, logging records, and other forest service data to narrow their search. They explored valleys that logging roads had not yet reached. What they found revealed not only the scarcity of old growth but also the fragmented condition of the heavily roaded eastside national forests.[90]

The activists did not always have an adversarial relationship with the Forest Service, which included many dedicated professionals. When Chuck Sisco, who oversaw the Adopt-a-Forest program, asked Bonnie Phillips to organize a conference in late 1987 in Everett, Washington, for example, she went to the Forest Service for help: "The first Ancient Forest conference I ever put together, for Adopt-a-Forest, I had to go to the local district ranger in Darrington because I had no clue how the Forest Service timber sale program worked or anything. Basically I threw myself on their mercy and said explain [this] to me. But I had some very good experience[s] with the people there."

In the Adopt-a-Forest campaign, Bonnie was not a mapper, per se, but as a coordinator, she ensured that the maps were produced and then used to great effect in the hand-to-hand encounters with Congress and the Forest Service to save the remnants of Washington's ancient forests.[91] Nevertheless, living on the doorstep of the Mount Baker–Snoqualmie National Forest and the timber town of Darrington had its harrowing moments, as was true for activists in other areas:

> *When I went to this Slade Gordon meeting, I got up to be interviewed by the local newspaper; they knew who I was. When I returned, the audience vacated three rows in front, three rows in back and all the way there…I almost got physically attacked on the way out. Then I started getting death threats on my phone and on my answering machine…[A]nd I never had it as bad as many people who lived in rural communities.*

By January 1989, ten paid mappers had been deployed in western Washington's national forests. Stage I maps, which showed existing and planned clear-cuts (managed stands), existing old-growth and mature forests combined and designated spotted owl habitat areas, were almost complete. Work was beginning on Stage II maps that would delineate true ecological old growth from mature stands, show the ages of second-growth stands and include information on other wildlife.[92]

Mount Rainier National Park. *Art Wolfe.*

On the east slope of the Cascades, mapping had been proceeding as well. The new Adopt-a-Forest inventories had found a 40 percent disparity in estimates of old-growth forest compared to Forest Service estimates. In 1989, Audubon mappers joined with forest supervisors to conduct updated inventories and field test the Forest Service's own reports. They found that less than 20 percent of the old-growth forests on the eastside remained.[93]

Through the mapping efforts, enough information was coming in to allow the National Audubon Society and the Wilderness Society to prepare the "first detailed list" of timber sales to protest. The list, drawn up in March 1988, served, in conjunction with the maps, as the basis for negotiations with Congress over what it was imperative to save. "Our hope is that by naming the places that we care about, the issue will be personalized to Congress, as it is certainly personalized to us."[94]

The Audubon maps were huge and often had to be spread out on the floor. After the old growth was mapped, layers showing important rivers and salmon runs, northern spotted owl and marbled murrelet locations, rare plants and other interesting data were added with each having its own layer. Despite their cumbersome quality, these maps were indispensable: they

allowed environmentalists to effectively challenge the "expert" status of the Forest Service in its forest inventories and designations.

On a related front, in November 1988, district court judge Thomas Zilly handed down an early court decision in *Northern Spotted Owl v. Hodel*, in which he said that the U.S. Fish and Wildlife Service (FWS) decision not to list the spotted owl had been "arbitrary and capricious and contrary to the law" since it cited no scientific evidence. Some refer to his ruling as one of the environmentalists' greatest victories. Soon after, in April 1989, the FWS proposed that the spotted owl be listed as endangered under the federal Endangered Species Act.[95]

MELANIE ROWLAND AND SEATTLE AUDUBON: LOGGING IN THE COURTS

The FWS proposed listing of the spotted owl did not change much in the short term. There was still a long public process to go through before an ultimate decision was reached. Tired of waiting for listing of the owl, in the spring of 1991, the Seattle Audubon Society and eight other environmental groups filed suit in Federal District Court, claiming that the Forest Service had not met the requirements of the 1976 National Forest Management Act (NFMA) and seeking an injunction to halt all timber sales. Bob Grant, chair of the Seattle Audubon Society Conservation Committee, and new recruit to the committee attorney Melanie Rowland met with Sierra Club lawyers Vic Sher and Todd True to discuss a potential lawsuit.

The legal challenge succeeded on May 5, 1991, when Judge William Dwyer ruled "that the problem here has not been any shortcomings in the laws, but simply a refusal of administrative agencies to comply with them." The decision granted a preliminary injunction preventing logging in all Washington and Oregon national forests until the Forest Service wrote a Forest Management Plan that met NFMA requirements. Subsequently, the Ninth Circuit Court of Appeals upheld Judge Dwyer's injunction and required the Forest Service to produce an acceptable management plan by March 1992. The injunction blocked 140 pending timber sales, comprising nearly one billion board feet of old-growth forest. Its impact was not as draconian as it may have appeared to the timber companies, though: Judge Dwyer estimated that those companies already had enough timber under contract to keep them logging for another two years.[96]

Melanie Rowland skis in the Methow Valley. *Provided by Melanie Rowland.*

Melanie Rowland, who was at the right place at the right time, would soon become not only the coordinator and media contact for the litigants but also a national figure as the representative of Audubon's Seattle chapter and environmentalists in the endgame to save the ancient forests. Born in San Diego, California, in 1950, she moved to Seattle after finishing Stanford Law School. She traces her interest in the natural environment to her mother, who had gone to Africa on an Audubon trip and was a supporter of progressive causes: "My mother...really got me interested in the environment—and population. I gave the valedictory address at my high school in 1967. And I was sitting at the kitchen table: 'What am I going to talk about, Mom?...She said, 'Talk about the population! It's going to ruin the world!' I said, 'Ah, yeah.' This was 1967. So I did."

After nine years as a lawyer at the Federal Trade Commission, Rowland decided that she wanted to get involved with environmental work. She called Seattle Audubon in 1988, and the organization told her about a conservation committee meeting the next day.

I remember that at that meeting he [Bob Grant] *said that he was going to go meet with Vic* [Sher] *and Todd* [True] *at the Legal Defense Fund to talk about a possible lawsuit regarding the spotted owl. And, well, there I was, a lawyer. And Bob said, "Do you want to come with me?"* [My first reaction was,] *"What's the spotted owl?" I didn't know anything about it. Could have been a barn owl as far as I was concerned. And then I learned about ancient forest habitat. And that was the beginning…The key to ending the logging of old-growth forests was the National Forest Management Act* [that] *requires the Forest Service to "provide for diversity of plant and animal communities"…The lawsuit that we were talking about with* [the] *Sierra Club Legal Defense Fund didn't have anything to do with* [the] *Endangered Species Act because the Spotted Owl was not listed as threatened until 1990 after there had already been the injunction based on the National Forest Management Act.*

Two issues—the NFMA requirements for viability, which in Washington was linked to spotted owl habitat, and the owl listing controversy under the Endangered Species Act—were converging at this point.[97] With seven federal agencies, four national environmental groups, the congressional delegations of two states and the courts, the complications were endless. In May 1991, the Forest Service submitted a revised Forest Management Plan to the Ninth Circuit, based in part on recommendations in a 1990 report by the Interagency Scientific Committee (ISC), composed of the best owl scientists in the Pacific Northwest and chaired by Jack Ward Thomas, head of the Forest Service research station in La Grande, Oregon. The Seattle Audubon Society challenged it. In the organization's view, it still did not meet NFMA requirements because the Forest Service did not act on the scientists' full report, which had substantiated the claims of the environmental groups. Judge Dwyer held two weeks of hearings, in which an expert on the northern spotted owl revealed that the Forest Service had refused to act on the advice of biologists due to "considerable political pressure." On May 23, 1991, Dwyer required an environmental impact statement be drawn up for the new plan and issued a permanent injunction preventing all logging in Northwest national forests until the Forest Service adopted a scientifically supportable plan.[98]

Throughout this period (1987–91), the environmental organizations continued to contest not only the owl statistics released by the timber companies but also the estimates of job losses it was claimed would follow the listing. The timber industry research group Northwest Forest Research

Council estimated a tidal wave of job loss—290,000 jobs—whereas the estimate by reputable scientists was just 4,000 jobs.[99]

The controversy over listing the spotted owl ended only after the so-called God Squad escape hatch to the Endangered Species Act was exercised by Manuel Lujan, Bush's secretary of the interior, in May 1992. The clause allowed a committee of relevant cabinet-level heads plus one member chosen by the president to vote to exempt a species from protection if it judged the cost to society too high. The God Squad gave a green light to some timber sales, but with a caveat: the existing plan had to be followed until the Department of the Interior could come up with another. Due to a complicated interplay of factors, the Bush administration never proposed a comprehensive forest plan before leaving office in January 1993. In essence, nothing changed. The owl was safe for the time being.[100]

The Ancient Forest Alliance Calls Up the Volunteer Army

While these developments were occurring in the courtroom and in federal agencies, local Washington, Oregon and California environmentalists, having grown increasingly frustrated by their own congressional delegations' resistance to taking action to protect old-growth forests, decided it was time to initiate a national campaign and mobilize their volunteer army. In September 1988, they held a conference, funded by the Wilderness Society, to which they invited top-notch activists. At the conference, they created the term "ancient forests" to replace the sometimes pejorative "old growth" and decided to seek a legislative solution that would preserve the Northwest's remaining ancient forests.

The term "ancient forests" became a media coup. Dead trees walking (old growth) morphed into ancient druids from the distant past, described by William Dietrich as a "shattered regiment." The Ancient Forest Alliance came into being, and conservation activists in the Pacific Northwest were galvanized into action.

The Ancient Forest Alliance was a loose coalition of environmental groups, with a steering committee that oversaw the campaign; a national committee in Washington, D.C.; and activists in three states—Washington, Oregon and California. In the nation's capital, representatives of the Wilderness Society, the Sierra Club, the National Audubon Society, the

National Wildlife Federation and the Sierra Club Legal Defense Fund, along with grass-roots representatives from the three affected states, met weekly to discuss strategy. Bonnie Phillips was the representative for Washington State. To strengthen coordination, there were conference calls with state activists at least once a week to talk about strategy and keep everyone updated on progress.

The alliance's national committee was tasked with negotiating with Congress as well as the Pacific Northwest delegation, including Northwest power brokers Representative Tom Foley, Senator Mark Hatfield and Senator Robert Packwood. In addition, the alliance met with potential champions for conservation from other states, such as Senator Patrick Leahy of Vermont, Representative Gerry Studds of Indiana and Representative Jim Jontz of Nebraska. Members of the Pacific Northwest delegation were, for the most part, willing captives of the timber industry and often led the charge for the opposition. The Ancient Forest Alliance, therefore, had to seek sponsors for forest bills in states that did not have a stake in the outcome.

An important strategy difference soon emerged in the forest campaign, however. Grass-roots activists wanted all of the nearly two million board feet of timber in owl habitat protected. Local groups felt the national representatives were ignoring their arguments to stand firm. The national representatives, however, felt that they should remain in the driver's seat because, after all, they were the ones who knew how to negotiate with members of Congress. Through such negotiations, the national groups hoped to avoid a major backlash against forest protection—vainly, as it turned out. Furthermore, Senator Mark Hatfield (Republican, Oregon) had attached a rider, dubbed by conservationists the "Rider from Hell," to the 1990 Senate Appropriations Bill, which was subsequently passed into law and was designed to negate the effect of Judge Dwyer's injunction under the NFMA and allow logging to resume.

Using the Adopt-a-Forest maps, the Ancient Forest Alliance negotiated with Hatfield and, under immense pressure, agreed to a compromise. There would be a total of 800 million board feet cut, but which forests to cut and which to protect would be decided through further negotiation. The tug of war would then focus on who would select the timber areas to be saved—environmentalists or the Forest Service.[101]

Bonnie Phillips and the
Western Ancient Forest Campaign

In 1991, several environmental foundations—the Lazar, Bullitt and Alton-Jones Foundations and the Pew Charitable Trust—clearly recognized the growing chasm between the negotiators based in Washington, D.C., and the local activists. They met with regional activists, including Bonnie Phillips, to talk about funding a regional grass-roots activist network. Phillips described her experience:

> [W]hen the foundations were saying that we were not all treated as equals I was like, I know that, so they invited me for Washington State, James Monteith and Julie Norman for Oregon and Tim McKay from California to a meeting in Portland and offered to fund a new group, which was then called the Western Ancient Forest Campaign—a new group that would have grass-roots representation in Washington, D.C.

Melanie Rowland, by then on staff for the Wilderness Society, was possibly the only person who could view each side with some objectivity. She had been part of the grass-roots action and now served as a liaison between the activists in the recently formed Western Ancient Forest Campaign and the Washington, D.C. contingent of the Ancient Forest Alliance, as members of each group worked to save the forests.

Neither the state activists nor the national representatives could get beyond their own point of view, she noted: "Each one thought the other one didn't know anything, basically. And the truth is that, everybody knew something important…and they should have been listening to each other more than they were."

She captured perfectly the single-minded devotion of forest activists:

> They're looking at one piece of the country, one issue, and it is so important in their lives that they are willing to give up practically everything else… Their environmental group is their family, and the forest is their family. And the reason they are willing to make a shambles of their personal lives spending thousands of hours working as volunteers in environmental organizations is that they are passionately, passionately dedicated to keeping the forests alive.

President Clinton and the Western Forest Summit

As the stalemate between activists and supporters of logging interests continued and the local fights became increasingly bitter with threats of violence against forest activists, the Pacific Northwest's ancient forests became an issue in the 1992 presidential campaign. Democratic candidate Bill Clinton promised the labor unions, concerned about job losses in the timber industry, that he would resolve the stalemate at a forest summit where all parties would be represented.

The promised summit, the Northwest Forest Conference, convened on April 2, 1993, in Portland, Oregon. President Bill Clinton, Vice President Al Gore and six cabinet members arrived in the pouring rain. Outside were rallies of pro-forest and pro-timber activists. Each side held press conferences in front of a horde of media. The next day, fifty-four invited speakers participated in three conference panels with several hundred invited participants sitting around a large table.

Melanie Rowland, who attended the conference, reflected on how much had changed "since 1987, when there generally wasn't a peep about any of this":

> [T]*he timber industry had been flattening the forests for a couple of decades at that point. In 1993, you've got the President, the Vice President, and half the cabinet in Portland, talking about it, saying, "Something's going to change." [R]egardless of any substantive outcome, the fact of a new, Democratic, environmentally friendly administration that was paying so much attention to this issue was just incredible to me. And then the outcome was the Northwest Forest Plan.*

The administration had asked for a range of options from the Forest Ecosystem Management Assessment Team (FEMAT), a large group of scientific experts headed by Jack Ward Thomas. FEMAT came up with eight, but none was deemed both politically viable and likely to meet Judge Dwyer's requirements to lift the injunction. Not only that, but the timber industry was still clamoring for a cut of 2.0 billion board feet. FEMAT then came up with Option 9, released on July 1, 1993, which stressed a new, still experimental approach touted by the well-known scientist Jerry Franklin and based on his study of the ecology of old-growth forests. It was called "restoration forestry" and featured aggressive thinning of second-growth forests, 1.2 billion board feet annually, including one-third old-growth trees

and trees cut in other practices, such as salvage logging, if it contributed to forest health.[102]

The administration submitted a final plan to Judge Dwyer in the spring of 1994, including some increased protections, added in response to public comments. Just before Christmas of that year, Judge Dwyer ruled that Option 9 complied with federal requirements, if barely. The permitted forest cut half what big timber wanted, but it made substantial inroads on remaining ancient forests.[103]

Many in Congress considered Option 9 a victory for conservationists. Environmentalists did not. There was a vigorous debate among environmental groups about whether to support the deal. But with Option 9 on the table, the Clinton administration pressured environmentalists to no longer contest 200 million board feet of timber sales then held up by the court injunction. This would be seen as a gesture of good faith, they were told. Many environmentalists believed that if they did not comply, the administration would follow through on its threat to support legislation declaring Option 9 immune from legal challenge. After much debate, when the Adopt-a-Forest maps again proved invaluable, 83 million board feet were released for sale.[104] In June 1994, Judge Dwyer lifted the injunction, and timber sales and logging recommenced where permitted.

HELEN ENGLE: SALVAGE LOGGING AND CIVIL DISOBEDIENCE

The three-year injunction on logging in the Northwest was followed in the late summer of 1994 by wildfires that roared through the drought-weakened forests of Washington and Idaho devastating 1.5 million acres. Local politicians began campaigning for a huge "salvage logging" effort to cut these forests and capture their economic value.

In November 1994, the Republican Party swept into power in the House and Senate with an anti-environmental agenda. Ecosystem management was out and political and economic interests were in. The timber companies mounted a public relations offensive blaming radical environmentalists for the fires and most everything else. In Congress, the powerful enemies of conservation Senators Hatfield from Oregon, Craig from Idaho and Gorton from Washington and Congressman Norm Dicks (Democrat, Washington), posing as saviors of the national forests, seized this opportunity to force a salvage-logging bill through

Congress in the form of a rider to an appropriations bill. The rider also included a provision to open for logging all previously protected timber sales from the 1989 "Rider from Hell," no matter the consequences for old-growth forests. The 1995 Emergency Supplemental Appropriation and Rescissions Act, which contained this rider and was supported by Congressman Dicks, was at first vetoed by President Clinton, but subsequently he caved under pressure and signed the bill in July of that year. What followed was termed "logging without laws" by conservationists.[105]

The Forest Service developed a massive salvage-logging program to supposedly remove dead and diseased trees that presented a fire hazard. The stated objective was to save timber jobs. Unfortunately, the Forest Service personnel who delineated the proposed timber sales did not know these forests well—and, in some cases, had never been there. Many of the sales included large numbers of healthy old growth trees rather than disease-ridden trees that would provide less valuable timber. (A typical practice of the Forest Service was to "salt" every sale, proposed for whatever purpose, with plenty of big healthy trees to satisfy the timber industry.)

The environmentalists' only option now was civil disobedience. The Western Ancient Forest Campaign and its allies scheduled a demonstration, organized by Susan Prince and Catherine Lucas, on October 30, 1995, at the Sugarloaf timber sale in the Oregon Siskiyou Mountains. The demonstrators included several mainstream environmental leaders—Brock Evans; Jim Jontz, then executive director of the Western Ancient Forest Campaign; and Charlie Ogle of the Sierra Club. It was a sunny late-autumn day—perfect for getting arrested. The activists infiltrated the barriers set up by the Forest Service, evaded their troops and chained themselves to trees. Ninety people were arrested, among them Brock Evans.[106]

A month later, local activists, including Adopt-a-Forest alumnae Alex Bradley, Bonnie Phillips and Mitch Friedman (now with the Northwest Ecosystem Alliance), gathered in Port Townsend to plan a campaign to influence Dicks, who appeared to not know that sales on the Olympic Peninsula would be affected by the bill he supported. In December, Helen Engle, as a member of the National Audubon Society's board of directors and one of the nation's most effective environmentalists, took the fight to the Audubon boardroom to gain support for those who had been arrested attempting to stop logging at the Sugarloaf timber sale. As she recalls:

> So I...said, "We have read every EIS [environmental impact statement]; we have appeared at every public hearing; we have written

our professional, scientifically based positions over and over and over. We have jumped through every hoop, and we are getting nowhere. We are losing old-growth forests so fast that it scares you"…My grandmother did civil disobedience to get the vote for women, I feel totally safe in doing some civil disobedience…Auduboners are trained. We do not hurt people; we do not damage property; we just protest the issues. Then I told them about [the arrest of] Brock Evans, and this is why Brock has been our champion. "Chairmen of the board…I'm going to ask for a vote from each of you on the support," and I thought, well, I'm dead…Well, they went around the room, and it was unanimous.[107]

Then, in January 1996, Helen Engle led an unprecedented sit-in at Congressman Norm Dicks's office in protest of his decision to favor the salvage rider: "I worked on Norm Dicks on that one. He voted wrong and I got a whole bunch of people together, and I [said]…we're going to go down and we're going to go to his office and insist on a meeting with him, and insist on him talking to us…And then I told them I want you to wear your power suits, and absolutely no gestures, no posters, no hanging stuff on the walls."

The staff called the congressman in D.C., saying:

"My God, Helen Engle's here with a whole bunch of people, what am I supposed to do?" And Tim [Audubon Washington scientist] said, "You've got to talk to her," and so [Dicks] came on speakerphone, and we said, "We really want to meet with you in person." We want to talk about this, and we've got some really good people who've worked hard on this issue for a long time, [and] a good scientific position…and he said, "OK, set up a meeting." So we had the meeting here at my house.

Helen Engle and Norm Dicks were not strangers to each other when Helen showed up at his office in January 1996. They had grown up in Washington politics together. When Dicks, then an administrative aide to environmental champion Senator Warren Magnuson, decided to run for a newly vacant seat in Congress, Engle was one of his first supporters and subsequently worked with him on many issues. Dicks became a key ally during the national campaign to save ancient forests, yet to the dismay of Helen Engle and other activists, he had voted for the 1995 "Salvage Rider."

The meeting held at Helen Engle's home was standing room only. She had assembled a cross section of conservationists to talk about the scientific reasons to oppose salvage logging. There were fish people, there were bird

Helen Engle. *Michael Peterson Photography.*

people and, of course, there were ancient forest people. After hearing this testimony, Norm Dicks changed his position on the spot.[108] The final straw was a leaked memo from the House Republican leadership advising its members in the Northwest to go over the heads of the "elitist" environmental movement and stage tree plantings or beach cleanups to woo constituents.

Throughout the 1980s and 1990s, the Forest Service and the other land management agencies attempted to bargain with nature—and reality—by gradually reducing the acreage of habitat set aside for owls, ignoring the 1981

Interagency Science Committee recommendation for about two thousand acres per breeding pair. By 1995, because of the Hatfield rider, no habitat had been protected. And the owl population had continued to decline.

But mother nature bats last. February 1996 saw the worst floods in thirty-two years in Oregon and Washington. Water rushed down the recently cut slopes filling streams with muddy runoff and debris. In that same month, President Clinton, at a rally in downtown Seattle, demanded repeal of the 1995 salvage-logging rider. This did not happen, but the provisions of the rider did expire after one year.[109]

In January 2001, just before leaving office, Clinton signed the Roadless Area Conservation Rule, which prohibited road building, logging and mining in 58.5 million acres of "inventoried roadless areas"—including some national forests. The legislation was a great boon to Washington, where road building was the first blow to wilderness areas. Environmental activists had helped to establish a new cultural reality. The ancient forest campaign had educated the public about the value of the natural world and helped to change the culture of the Forest Service so that it could accommodate a world in which the ecosystem has a value beyond the dollar value of timber. The annual timber cut allowed in the forests of the Pacific Northwest had been reduced to less than a quarter (1.2 billion board feet) of its previous levels. Old-growth forests and even the northern spotted owl had a future.[110]

Brock Evans, who had participated in just about every Washington State environmental campaign in the previous forty-five years, declared the Ancient Forest Campaign the greatest victory of them all, given the forces arrayed against it.[111] While the achievement was less than a number of environmentalists hoped for, it was still a significant advance in preserving the environment of the Northwest. In these struggles, the work of Bonnie Philips, Melanie Rowland and Helen Engle, among others, in behalf of Washington's environment was indispensable.

MANAGING GROWTH

THE STEEL MAGNOLIAS AND THE IRON LADY OF THE SENATE

A new environmental challenge emerged for the Puget Sound region in the late 1980s—rapid population growth. Between 1960 and 1990, 1,813,000 new residents came to Washington—a 41 percent increase in the state's population. All these people needed some place to live, and the Puget Sound area was a prime choice for many. The Washington Environmental Council reported that from 1982 to 1992, Washington lost to development more than two hundred acres of forests and two hundred acres of farmland *every day*, and there was no sign that the rate was diminishing.[112]

At the same time, women were emerging as leaders in the state legislature. By 1990, the six committees in control of land use issues in the house of representatives were all chaired by women. They were nicknamed the "Steel Magnolias" after the eponymous 1989 hit movie because of their style and toughness. A woman also led the state senate, the powerful majority leader Jeannette Hayner (Republican, District 16).

The six house committee chairs—Jennifer Belcher, Nancy Rust, Maria Cantwell, Busse Nutley, Ruth Fisher and Mary Margaret Haugen—brought their own brand of collegial leadership to the environmental issues facing the state. They would craft and pass legislation in 1990 and 1991 that allowed for growth and development but also protected farmland, forests and habitats through local government action. While the spotlight here is on them, other women also played leading roles in the struggle to contain urban sprawl, including Mary McCumber, chief planner of the comprehensive plan for King County that served as a model for some of the state proposals; the

Suburban development. *Istock*.

energetic Lucy Steers, who chaired Washington's League of Women Voters' Growth Management Committee; and the architect of the campaign to overcome the backlash to growth management, Dee Frankfourth.

As the state's population grew, anxiety about losing its natural beauty haunted many residents. Tom Campbell, who worked for house majority leader Joe King, recalled one popular rallying cry of the time: "Don't Californicate Washington." Representative King's personal encounter with a traffic jam in June 1987 was the catalyst for him to seriously consider legislation to manage sprawl.[113]

ROUND 1: THE FIGHT OVER THE FIRST GROWTH MANAGEMENT ACT

By 1990, the stage was set for growth management, in part because anxiety over losing the state's natural beauty to unchecked population sprawl increasingly haunted residents. Additionally, however, the state's powerful players slowly began to see that regulation could be in their self-interest, as policy advisor Tom Campbell explained: "[B]usiness interests…were essentially concerned about having the roads and the provisions that we

need for economic growth. Those in the environmental community wanted protection of critical areas and others in local government were looking for infrastructure funding…It came together into a broad basis of support for the Growth Management Act."[114]

If managing growth in Washington was an idea whose time had come, the moment still had to be seized. According to Representative Joe King:

> *I was Speaker of the House during that period, and I began meeting with my legislators…I had members of the House Democratic Caucus that had far more experience than I in thinking about these issues. So, I ended up assembling a group of six different committee chairmen. There was Busse Nutley chairing Housing, there was Mary Margaret Haugen chairing Local Government, Jennifer Belcher chairing Natural Resources, Ruth Fisher chairing Transportation, Maria Cantwell chairing Economic Development, and Nancy Rust chairing Environmental Affairs.*

It was King who nicknamed these women the "Steel Magnolias." The press loved the label, and it stuck. One of the six, Maria Cantwell, commented: "There's so much in that movie about the feminine and the power of that, that I don't mind [the name]. I just used to tell people, believe me, I'm not Dolly Parton."[115] Jennifer Belcher saw the label as a "subtle way of putting us down."[116]

Just three months before the 1990 session began, Belcher recalled:

> *I was one of the folks who first took the idea of some kind of a growth management act to the speaker. The initial conversation about doing it was between Maria Cantwell and myself. She was the chair of the Trade and Economic Development Committee and I was chairing the Natural Resources Committee. We met and talked about the incredible impact that population growth was having on the state and the need to do something… When we first went to [King] and talked to him about doing a growth management act, he kind of laughed and said, "Good grief. There's no way you're going to get something this big done without a couple years of planning. It's mid-fall. What makes you think you can do it in January?" We both said, "Well, we want to give it a shot. We have nothing to lose…" And Joe was…very supportive of his committee chairs. So he said, "Well, if you think you can do it, do it. Go put something together and let's get back together and talk about it.*

Speaker King continued the story:

So they began to work, and it was an unusual way to do the legislation. Normally a bill like that would go through one committee. We sent parts of it to each of the six committees to work on. On a policy basis, that was done to give it as comprehensive a look as we could. On a political basis, it was done to confuse our enemies and not give them a real clear target of what to shoot at. So after it came through all those committees, we then put it back together into one piece of legislation.

The six committee chairs were not politically a naturally cohesive group, even though they were all Democrats. But they were civic-minded women pursuing the same goal: to preserve the natural beauty of Washington State while allowing for development and economic growth.

The more conservative legislators in the group were Mary Margaret Haugen (District 10), chair of the house Local Government Committee, and Busse Nutley (District 49), chair of the Housing Committee—both were very protective of the role of local government. Haugen represented Island County and parts of Snohomish and Skagit Counties, home to dairy cows and tulips north of Seattle. The district was, and still is, largely rural, with many voters concerned with protecting private property against state interference. A distinguished, white-haired woman in her late forties at the time, she had been very active in the League of Women Voters and had been first elected to the house in 1982.

Busse Nutley grew up in Yakima but moved west and shared representation of southwest Washington's Forty-ninth District with Joe King. Before election to the house in 1985, she had worked for the home builders association—a group normally against government planning and regulation. Her expertise in housing and planning came to the fore in the growth management debate, which seesawed between Haugen and Nutley on one side and the two most liberal female chairs, Jennifer Belcher of Natural Resources and Nancy Rust of Environmental Affairs. Between Haugen/Nutley and Belcher/Rust politically were Ruth Fisher and Maria Cantwell.[117]

Fisher (District 27), first elected to the Washington State House in 1983, was characterized by the *Seattle Times* at the time of her death as "an ardent liberal."[118] Over the years, her blunt style and acerbic sense of humor had made her the doyenne of state transportation. There was one way to do transportation planning, and that was Ruth's way. Nevertheless, in Busse Nutley's words, "It was a lot of fun because she was a good,

From left to right: Mary Margaret Haugen (second from left), Speaker Joe King, Maria Cantwell and Jennifer Belcher. *Washington Office of the Secretary of State.*

strong advocate of doing the right thing. And she always had great humor about the whole thing.

Maria Cantwell (District 44), first elected to the state house in 1986, represented part of the rapidly developing Puget Sound area and had developed great affection for the state:

> *I moved to the Northwest in 1983…I'm not saying there wasn't an environment in Indianapolis, but to move from Indianapolis to the Pacific Northwest is like the great awakening. I remember people talking about areas of Seattle that they thought were the less desirable places to live, and then going there and seeing that they had a view of Mount Rainier, and I just couldn't even fathom it…how unbelievably lucky everyone was to have a view of the beautiful environment here. [T]hen I met two really great people who were inspirational to me in their passion and love for the environment…Hazel Wolf and Brock Evans…[Hazel] was a tour de force…every day you spent with Hazel was enlightenment, joy.*

Jennifer Belcher (District 22), representative from the Olympia area, was well known for her liberal views and her commitment to environmental conservation and the protection of natural resources. She had moved to Washington in 1967 from West Virginia when her boss, urban planner

Busse Nutley. *Washington Office of the Secretary of State.*

Richard Slavin, was hired by Governor Dan Evans to prepare a state land use plan. She went on to work directly for Evans and then, in 1977, for Dixy Lee Ray, his successor. Belcher served as the liaison between the governor and various state agencies and as the governor's liaison to the state legislature on the passage of the Equal Rights Amendment. When Belcher decided to leave the governor's office, Ray recommended she run for office, perhaps as superintendent of public instruction. Belcher took the advice but ran instead for a seat in the house to which she was elected in 1982.

Like Maria Cantwell, Nancy Rust (District 1), the sixth of the Steel Magnolias, represented a district in the Puget Sound area. Born in Iowa in 1928 and brought up in Connecticut, she married a physician. They moved to Seattle, where they raised six children and Nancy was active in the League of Women Voters.[119] Upon her election to the house in 1980, Rust was asked to chair the Committee on Environmental Affairs, a position she held for twelve years. A strong and steady force in the house, she had a knack for reaching across the aisle to work with her Republican colleagues.

As remarkable as the accomplishments of the Steel Magnolias was the process of their collaboration. When asked about the dynamic of six female committee chairs, Busse Nutley commented: "[W]e just thought that [having female committee chairs] was the way things should be. It was interesting because the six women who were in charge of the six committees happened to be six of the most opinionated women in the House. None of us took anything Joe King had to say easily. We were a challenge to him and he seemed to enjoy every minute of it, so it was a lot of fun actually."

And according to Jennifer Belcher:

It was an incredible process. We had not attempted anything quite that large before. You can imagine the controversy that surrounded doing this, and the idea that you could take six separate bills and work them through six committees and then bring them back together was rather unique, as well. It didn't occur to us at the time that we were all females. It wasn't an issue with us. We were just committee chairs who put this all together and somebody came up with the notion that this was really unique because we were all women.

And Tom Campbell, legislative assistant to the Speaker, noted:

Here you had six incredibly strong, very potent women, each in her own right going further with her own work and career…So it was a wonderful time to rely on their strengths—but also to contend with a unique brand of female ego. Something you might call territories. These women had good strong elbows but also knew how to compromise and get along with the speaker. If there were conflicts that couldn't be resolved, they were assuaged by Joe King. I had the job of shepherding all of the six components and bringing those pieces [together].

After the six committee versions of the bill were melded into a unified version, it was considered by the full house and passed. The Growth Management Act then went to the senate, where there was a moment of humor—not without a bite, as Belcher recounts:

[T]he Senate was less than receptive to the six of us coming over from the House. The chairman of [the relevant] *committee was rather rude to us* [and said,]… *"The ladies from the House have come over to tell us senators what we need to do about growth management." Ruth Fisher…let him know in no uncertain terms that we were not "the ladies from the House." We were six committee chairs that had responsibilities equal with his own and that…had something serious to talk about. But it was…interesting…to watch Ruth and this committee chairman go at each other, because they were not compatible in thinking about Growth Management.*

THE DEAL MAKER:
THE IRON LADY OF THE SENATE

Jeannette Hayner. *Washington Office of the Secretary of State.*

In the senate, it was another woman, Jeannette Hayner, the Republican majority leader, who ensured passage of the growth management bill.

Jeannette Hayner was "fondly" called the "Margaret Thatcher of the Washington State Legislature," King recalled. "I would have to say that Senator Hayner was less than thrilled with the legislation. She had a State and Local Government chairperson who was a logical committee to send this to. That was Senator [Bob] McCaslin and he said basically over his dead body would he be passing the bill. So getting anything out of the Senate so that we could go to a conference was a real feat."

Born in Portland, Oregon, in 1919, Hayner received a BA from the University of Oregon and, three years later, was one of just two women to receive a law degree. She and her husband moved to Washington in 1947 and raised three children. Hayner ran successfully for an empty seat in the house in 1972. Elected in 1976 to the senate, she began to build a larger presence for Republicans and by 1979 had become majority leader. A small, slender woman with a sly sense of humor, she neither was a self-declared feminist nor became one of the boys; she let her competence and qualifications set her apart.

Hayner's concern about growth management legislation was that of a Republican—concern about increased regulation. She felt, nonetheless, that the people of the state wanted the legislature to do something to manage the growth and development that threatened the state's natural beauty. If anyone could ensure the bill ultimately passed in the Senate, Hayner could, said Haugen:

> *Jeannette was an extraordinarily wise woman. She came from Walla Walla, which is an area that, although it had growth problems at that time,*

a lot of people would not consider a high-growth area. But I think she was a bit of a visionary, she was a very strong leader in a time when women were not necessarily in leadership roles in the legislature…She was…a tough negotiator and she was willing to negotiate on growth management. She played a key role, as much as Joe King…she's the one that kept her caucus focused on the issue…Some people in her caucus at that time were not very supportive, but she told them, "We will do this. You will do it."[120]

Once the senate passed a version of the bill, differences had to be reconciled between the two versions. Lucy Steers gives much of the credit to Maria Cantwell: "[S]he was the one that went into the conference committee, and she was so smart and such a good speaker and so attractive that I think she just befuddled those old folks on the east side, the Republican men. And when the conference committee was finished, the bill was stronger than I think they intended it to be."[121]

The house and senate could not agree on the content of the bill before the regular legislative session ended on March 8, so Governor Gardner called a special session through April 1. A conference committee composed of senators and representatives reached an agreement on the last day of the special session. On the evening of April 1, 1990, the house (by a 72–21 vote) and the senate (by 32–16) passed the Growth Management Act. Governor Gardner signed it into law on April 24, although he vetoed fifteen of its eighty-nine sections.

A Counterattack

Environmentalists were not convinced that the 1990 Growth Management Act (GMA), even if passed, would have much effect. Those who wanted some teeth in the state's approach to growth management had crafted a ballot initiative called "Big Green," filed in March 1990 as I-547, in hopes of ensuring that the final Growth Management Act, which at the time was still being negotiated, would put state government in charge of approving local comprehensive plans and enforcing growth regulations. It was apprehension over just such "top down" management that pervaded the business and rural communities, however.

Hoping to reassure the environmental community and the general public, Jeannette Hayner crafted an open letter to Washington State residents. It was signed by the legislature's "four corners": herself as senate majority leader, house

majority leader Representative Joe King and the minority leaders of both houses. The September 28, 1990 letter stated that the 1990 Growth Management Act was "just the first step" and that a second bill would be passed in 1991 both to ensure state agency compliance with state planning goals and local land use plans and to provide a responsive governance process for resolving conflicts.[122]

Nevertheless, the environmental community decided to move ahead with its ballot initiative. Despite strong support for the Big Green initiative among conservationists, voters chose otherwise. The environmentalists "were absolutely convinced that they would win and they just got creamed," Belcher remarked. "Seventy-five percent voted against it. That was a very unfortunate move because they sent a strong message to the legislature that there was really no strong environmental community out there."

Round 2: The Struggle Over Enforcement

The attempt in the 1991 session of the state legislature to fulfill the promises of the "Four Corners" letter and strengthen the Growth Management Act turned into a pitched battle between the forces for growth management and those opposed. In particular, senate Republicans, not including Hayner, were dead set against strengthening the act with provisions for government accountability, criteria for siting large public facilities or anything else. Even within the house Democratic Caucus, there was dissension about which committee would control the bill.[123]

The session careened to a standoff with both sides holding their ground. With only eighty-two hours left in the session, Gardner stepped in. He sent a letter to the leaders of both houses urging an immediate negotiation, with Wayne Ehlers—a former house minority leader—to lead the deliberations. Lobbyists for all sides—developers, local governments and environmentalists—tried to influence the outcome. Representatives from the various interests met with the legislative leadership group in the governor's office. In the words of Ehlers:

> *Dick Ducharme, a powerful business lobbyist, said, "We're going to amend this [i.e., GMA] with all the weight that we want to put in it," and so forth. And everybody else chimed in. They agreed that they all had their agendas. And Jeannette Hayner leaned forward and said, "We run this place, you guys don't." And everybody in that room—Joe King, even*

Ballard who wasn't going to vote for it, and Gaspard said the same thing—
"We don't care what you're going to do, we're going to bring it up and we
think this is a reasonable compromise and we're going to go with it. So try
your best because [we're] *going to be successful."*[124]

The key provisions that strengthened the final bill were the establishment of Growth Management Hearings Boards to resolve conflicts, a provision for citizens to challenge local plans and a requirement that all jurisdictions identify critical areas (resource lands and wildlife habitat) as well as siting criteria for state and regional facilities.

A *Seattle Times* editorial at the time praised Jeannette Hayner's role: "Whatever her personal doubts, Hayner respected and responded to strong public sentiment for growth management legislation with backbone. Powerful businesses and government lobbies pushed hard in the other direction, but Hayner refused to budge, and she held the Senate Republicans together. A gritty performance."[125]

BACKLASH

The second and final Growth Management Act (GMA) passed in 1991. Almost as soon as the governor's ink was dry, some within the industry and business communities set in motion an orchestrated campaign to weaken or repeal the act, reaching a peak in 1995 with a "Property Rights" Initiative.

The political backlash against planning and regulation in the United States, of which this was a part, dated back to the 1970s, sparked by the passage of strong national environmental laws: the National Environmental Policy Act, Clean Air Act, Clean Water Act and the Endangered Species Act. These laws ended decades of laissez-faire policy in which the absence of safeguards led to serious environmental destruction, including damage to rivers and estuaries caused by runoff from clear-cutting forests. By the 1980s, the national consensus was clearly behind encouraging a "clean" environment. Opponents of environmental laws realized they could not attack environmental protections head on. They needed another strategy and found it by stretching the interpretation of the "takings" clause of the Fifth Amendment.

Chicago University Law professor Richard Epstein, author of *Takings: Private Property and the Power of Eminent Domain*, argued, for example, that

regulation for *any* public purpose—regardless of any need for environmental protection or public health—was a "regulatory taking." President Ronald Reagan and his interior secretary, James Watt, adopted this philosophy. Their support immediately conferred credibility on the so-called Sagebrush Rebellion. In the words of one report: "By turning even simple regulations into 'takings,' the entire issue could be transformed from a losing argument over rolling back environmental laws to one of 'protecting the little guy from big government' and 'individual liberty, freedom and property'—what made America great."[126]

Small but vocal anti-government and anti-tax groups gravitated toward this so-called Wise Use approach. Some agitated, unsuccessfully, to separate rural parts of several central Puget Sound counties—King and Snohomish, for example—from the urban areas. Snohomish's new rural jurisdiction was to be called "Freedom County" and the new portion of King County, "Cedar County."

An electoral sweep by Republicans in the fall of 1994 changed the balance of power in the Washington State legislature and allowed the anti-takings campaign to gather momentum. Big funders—builders, timber companies and real estate interests—saw their opportunity to submit an initiative to the legislature, which would require only 181,000 signatures, as compared to the 231,000 needed for a ballot initiative to the voters. Initiative 164 (I-164) would require compensation at fair market value for loss of any property value due to any land use action by government, including zoning. The funders' money enabled the "I-164 Committee" to hire a California firm that paid signature-gatherers one dollar per signature. The effort had limited but sufficient popular support: the Wise Use committee was able to gather only 2,600 signatures more than the required number. The measure moved to the legislature for its vote.

Mary Margaret Haugen, now a state senator and chair of the committee with responsibility for the bill, was the last line of defense for proponents of meaningful growth management. Haugen believed a measure as important as I-164 should be voted on by the people rather than enacted by the legislature. She scheduled the bill for a public hearing, not a vote. In response, two conservative rural Democrats joined with Republicans in a rarely used procedure to pull the bill from her committee and send it to the floor without a committee vote, just before the legislature adjourned. On April 18, 1995, Initiative 164 passed the senate 28–20. As an initiative passed by the legislature cannot be amended or vetoed, I-164 would become law ninety days after the end of the session. The only way to overturn the new

law was to collect signatures for a referendum to put the issue on the ballot for a vote by the people.

NO ON REFERENDUM 48 CAMPAIGN

The day after I-164 passed the state legislature, Lucy Steers, immediate past president of 1,000 Friends, a nonprofit she and others had organized to defend the Growth Management Act, drove to Olympia, wrote a check for the

Dee Frankfourth. *Provided by Dee Frankfourth.*

required fee to file a referendum measure with the secretary of state and held an impromptu press conference with fifty Democratic legislators. GMA supporters who had originally met as "No on 164" now became the "No on [Referendum] 48" Coalition. (I-164 as enacted had become R-48.) They had barely three months to gather the needed signatures to get their measure on the November ballot.

The day the ballot measure was filed, Dee Frankfourth was hired as campaign director. It was a good choice. Born and raised in Alaska and educated at Washington's Evergreen State College, Frankfourth had held politically sensitive environment-related jobs in Alaska and the nation's capital and had served as campaign manager for Jolene Unsoeld's Washington congressional campaigns. She quickly hired staff and opened an office in Seattle's Pioneer Square. The campaign now had only seventy-seven days to gather signatures. One question was whether to hire paid signature-gatherers as the proponents of I-164 had done. But the League of Women Voters would not endorse the campaign if that were the policy. Fortunately, many rallied around the cause and paid signature-gatherers were not needed: "No on 48" had upward of ten thousand volunteers and supporters.[127] The organizers hoped that this grass-roots volunteer petition drive would create the momentum and infrastructure needed to defeat the referendum.

The signature-gathering effort was a thing of beauty. Every detail was planned and executed to perfection. The effort led to one of the most successful signature drives in state history, gathering 231,112 signatures, which were duly submitted on July 21, 1995, and found sufficient to get the referendum on the ballot.

That spring, though, polling had shown that 75 percent of the electorate agreed that "government agencies should be required to pay a landowner for any drop in property values resulting from regulations." Clearly, "No on 48" had a lot of work to do by November 7 to change public opinion.

In early September, a big boost to the campaign came when a team of researchers headed by respected University of Washington economist Glenn Pascall released a study showing the budget-breaking flaws of Referendum 48 should it be allowed to stand:

First, R-48 would actually intensify the worst aspect of land-use regulation in our state and region—it would add to the delays caused by complex requirements. Second, R-48 would spend millions on compensation for those who don't want or need it, and fails to compensate other property

owners for the losses in land value it would cause. Third, the cost burden it would impose could add 5 percent or more to the taxpayer cost of funding local governments, and the cost it creates could add much greater taxes on top of that. R-48 is a lifetime employment act for land-use attorneys and economic consultants. It is a case of throwing vast amounts of money at a problem to reach a relative handful who need help.[128]

Campaign director Frankfourth said the campaign's message was clear and simple: "It goes too far, it costs too much, and neighbors say no." That November 1995, Referendum 48 was submitted to the voters. The final tally was For: 544,788; Against: 796,869. I-164 was nullified.

The women who worked to pass growth management legislation were at the leading edge of the equal rights movement and reaped the benefits. Successful negotiation of the Growth Management Act in 1990 and 1991 was almost a miracle. Washington legislators had managed, as in the fairy tale Rumpelstiltskin, to spin the straw of conflicting interests into gold. And their subsequent work, along with the concerted efforts of many others, had led to its defense across the state.

PROTECTING WASHINGTON STATE FORESTS

JENNIFER BELCHER AND MARCY GOLDE

Throughout the twentieth century and into the twenty-first, two powerful blocs in Washington State, the timber companies and the state trusts (including the University of Washington), have been eager for immediate income from logging publicly held state forests. At the same time, environmentalists have wanted to protect remaining old-growth forests and to promote sustainable forestry. State environmental groups deployed science, environmental laws (that they helped to pass) and targeted lawsuits to stop practices that were destroying forests. But progress was slow, despite years of skillful negotiation with Marcy Golde, chair of the Forestry Committee at the Washington Environmental Council, leading the team. In 1992, the election of Jennifer Belcher as state lands commissioner, a position of considerable power over state forest policies, would change everything.

In 1986, all parties had entered into a series of formal negotiations. Conservation principles very gradually gained ground, but the road was long and difficult. The power imbalance between environmentalists on the one hand and timber and state trusts on the other was huge. The timber industries had the wherewithal to hire many lobbyists at the state legislature, a seemingly unlimited payroll for negotiations and a public relations budget. The state trusts had a great deal of prestige to put on the table and considerable influence of their own. Picture three cars driving from Seattle to the state capital in Olympia. The first car is a limo full of lobbyists, lawyers and consultants. The next car is a tasteful dark-colored Ford sedan

with several University of Washington (UW) trustees inside. The third car is a Dodge Volt with four environmentalists, including a lobbyist.

When Washington was admitted to the union in 1889, the state received 3.2 million acres (not including aquatic lands) from the federal government. The lands were transferred to state ownership as "state trust lands" for the "express purpose of the states using them for funding of schools, universities and other public purposes."[129] Some of these lands were sold, but 2.8 million acres of upland trust lands and an additional 2.1 million acres of aquatic lands have remained under state management. Washington has more trust land acreage devoted to timber than any other land grant state. The revenue generated is the largest of any state and is a key source of income for Washington's public institutions. The state's Department of National Resources (DNR), established in 1957, manages these trust lands and is headed by an elected state lands commissioner. Its Forest Practices Board sets policy, including that for forest cuts, and is dominated by the trusts.

DEPARTMENT OF NOTHING REMAINING

During the twenty-three-year tenure of the first state lands commissioner, Bert Cole, a former logger and schoolteacher from the Olympic Peninsula, the DNR came to be known as the Department of "Nothing Remaining." An infamous and oft-repeated saying of Cole's was, "It will be cut sometime, so let's just cut it now." Timber companies had a stranglehold on the DNR during this period. Just as for the national forests, income was the most important criterion for the overseeing agency, so logically the priority use was logging. Local jurisdictions enthusiastically concurred. There was no concept of forest ecology. The DNR, the timber industry and University of Washington School of Forestry seemed to agree that "old growth" just meant old trees that needed to be replaced. Pulitzer Prize–winning author William Dietrich aptly captured the character of Cole's reign: "Bert Cole did not so much run the department (he had his good old boy deputies to do that) as preside over it. Given the job of converting some of the greatest forest left in the United States into tree farms, Cole became to the timber industry a benevolent baron. No one paid too much attention to how DNR went about its job in the 1960s and early 1970s, so long as the sale of public timber kept filling state coffers, and it did."[130]

The huge impact state forest practices had in this era is exemplified by the destruction of the pristine Clearwater Block (a DNR land designation) due west of Mount Olympus. Dietrich described it as the "biggest, densest, most untapped forest of old growth left in the State of Washington."[131] When Cole authorized roads to be punched through the Clearwater, frenzied cutting began.

Not surprisingly, the resulting extreme clear-cuts on steep mountain slopes spelled big trouble. In 1973, the Upper Clearwater drainage was cut so fast that hillsides began to slump. Because frequent landslides had already created a negative image for DNR, word came down from top department staff not to allow even a shovelful of dirt to get into the Clearwater River—orders that led to further extreme measures, wrote Dietrich: "The DNR crews went out into the rain and began unrolling [plastic sheets of Visqueen] across the hillside. They'd simply deflect the water from the soil. That, and log barriers and temporary flues to help divert the water, worked. The Clearwater stayed clear. Yet this was the ultimate absurdity, men wrapping the land in plastic to shield it from damage they had done."[132]

In 1980, a new lands commissioner, Brian Boyle, was finally elected. Though Boyle moderated the worst excesses, DNR employees were still commonly known as "timber beasts" because they continued to identify closely with the timber industry and its needs.

Mudslide near Pe Ell, 2007. *Washington State Department of Transportation.*

Marcy Golde:
Champion for State Forests

In 1979, Marcy Golde noticed a clear-cut near her Olympic Peninsula vacation home on the Quinault Indian Reservation and decided to investigate. The Bureau of Indian Affairs, the agency responsible for managing that land, was no help, so she turned to the Washington Environmental Council (WEC). According to Golde, "the next thing I knew, a wonderful woman…Marion Meacham, swept me up and said, 'We're taking a three-day tour around the Olympic Peninsula—don't you want to come along?' By the time I got back from that, she'd converted me and made an addict of me. And I've been working on forestry issues for the WEC as a volunteer ever since."[133]

A native of San Diego, Marcy graduated from Stanford University in 1956, married an electrical engineer who joined the University of Washington faculty and raised three children in Seattle's Laurelhurst neighborhood. Tall and willowy, Marcy is intense in demeanor and fairly vibrates as she telegraphs her passion for forests.

In the early to mid-1980s, WEC, the Sierra Club, Audubon and other environmental groups came together to oppose the liquidation of state forests, particularly old growth. WEC formed a Forestry Committee to pursue legislative advocacy, fieldwork and public outreach, and Marcy Golde became its chair.

Marcy Golde. *Washington Environmental Council.*

"Between 1986 and 1990 the forest cut on state lands skyrocketed to more than 800 million board feet per year. With prices soaring and the Japanese buying record amounts of Washington wood, the logging industry was enjoying a 'gold rush' for its product, though state and federal officials warned that the 'bonanza from their land could not last.'"[134]

In 1986, WEC and Audubon Washington entered into a series of negotiations that began with the Timber, Fish and Wildlife (TFW) negotiation and ended nearly two decades later, in 2005, with Forests

and Fish. During this period, the Department of Natural Resources, the timber companies, the state legislature and the governor kept conservationists at the table while, outside, the overcutting continued with few restrictions. These negotiations took up a lot of volunteer time and were a substantial drain on conservation community resources. But leaving them was never seriously considered because allowing timber companies to move on without the conservationists risked two bad options: a plan that would seriously damage the forests or a barrage of anti-environmental publicity.

At first, the environmentalists were not included in the TFW process but joined the negotiations later through the back door. Golde, the main WEC negotiator, considers this incident one of her "good" memories of TFW:

> One of the vice-presidents from Weyerhaeuser told me long afterwards that he had stood there and said, "No way, no how are the environmentalists going to be at the table." We had been invited to come in and discuss this with Jim Waldo, who was doing the mediation on it, the facilitation. [He] asked Pam Crocker Davis from National Audubon and myself whether we would like to be observers to that process and sit in the back of the room. And Pam and I sort of looked at each other, and we both said, "No, I don't think we want to be observers. You can either take us to the table, or we'll head for the hills and we'll be the guerrillas. Take it either way." And that was where the discussion ended from our point of view.

In the end, the Indian tribes, involved because of the effects of forest practice on the fishing rights to which they were entitled, forced the state and industry to invite the environmentalists to join the negotiations. Once at the TFW table, the environmental women—Golde, Judy Turpin, Crocker-Davis—together with Toby Thaler, an environmental attorney, made a substantial difference in the outcome of the process. The final TFW agreement reached in 1987 contained key compromises to encourage ecological forest management, most notably incorporation of watershed analysis in Forest Practices Permit applications and widened riparian management zones, though these provisions were only partially implemented in subsequent years.[135]

Following the 1987 agreement, Golde raised more than $150,000 in grants so that WEC and Audubon Washington could monitor the implementation of TFW. Eight WEC staff members and one from Audubon, plus grass-roots environmental volunteer activists, started reviewing Forest Practices applications. An application was now necessary to harvest timber; salvage logs, stumps or snags; or conduct other activities in state forests. Reviews

of proposed forest practices were a step forward but produced a huge workload—six to eight thousand applications per year to sift through—as environmental groups tried to challenge the worst among them.

The Forests and Fish process of 1996–99 represented the last round of negotiations to protect Washington's state forests. These were a response to the listing of the northern spotted owl as endangered under the Endangered Species Act. The final result was the Forests and Fish Report prepared without the participation of environmentalists. The DNR, the federal agencies, the state legislature and Governor Locke had made a separate peace, and the state legislature passed legislation that incorporated this report.

Scientists and environmentalists reacted to this with dismay. In an independent scientific review of the report, the American Fisheries Society (Western Division) and the Northwest Chapter of the Society for Ecological Restoration concluded that while some provisions were improvements over existing regulations, most provisions decreased environmental protection. Furthermore, said the reviewers, there was no evidence cited to support the new regulations.[136] Colleen Lee, chair of the Hoh Tribal Council, predicted that implementation of the report's recommendations would "continue to subject my community to the gradual extinction of our way of life."[137] And state senator Darlene Fairly in a 1999 letter to her constituents expressed a view of the Forest and Fish Report widely held by scientists and environmentalists: "Under the guise of 'adaptive management,' this proposal calls for low standards, which may then be tightened as scientists learn more about the habitat needs of salmon. This is a backward approach that risks the resource up front and allows for changes after damage has been done."[138]

THE 1992 CHANGING OF THE GUARD

When, in 1992, Brian Boyle chose to seek a state senate seat rather than a second term as lands commissioner, Jennifer Belcher decided to run for the position. Her candidacy was a long shot. Election pundits told her that in order to win she would need $1 million—an inconceivable sum to her and her supporters. As an environmentalist, she had no hope of receiving large donations from the timber industry or business. In fact her opponent, Anne Anderson, a conservative legislator from Whatcom County, was the timber industry's choice. With her outspoken advocacy of responsible stewardship

of state forests, Belcher, by contrast, appeared to the timber interests as their worst nightmare:

> *I believe that public lands are real treasures that we are fortunate to still have in public ownership, and that if managed properly, [they] can supply us with lots of things. They can make money for us. They can provide recreational opportunities, be the solitary places that we go to. They can be a lot of things to us, but we have to take care of them. [But] we are not into taking care of land. We are into using land. We are into abusing land. It always fascinated me that the law was set up not to protect resources, but to permit abuse of resources. The permitting laws tell you how much pollution you can pour into a river…Of course, the lobbyists are always working to change [laws] so we can put in more and more.* [139]

Belcher says that her interest in the natural world came through walks with her grandmother in the hills of West Virginia:

> *I had a grandmother who used to take us on walks in the woods of West Virginia. We would look for lady slippers and Indian paint brush and trilliums and all the wonderful old flowers. It was time to spend with our grandmother because we didn't see her all the time, and also to get outdoors. So my earliest involvement was learning the names of things with my grandmother and developing a real interest in the out of doors.*
>
> *Probably the next awareness level was of the strip mining in West Virginia where I grew up. The mining in the '50s and '60s was pretty incredible. There were very few regulations and they were strip-mining lots of coal and it was a really big issue. The impacts of that were fairly visible and my mom and grandmother and I and other members of my family were all upset about it. I was just a youngster. Those were the days before real activism—citizen activism.*

How did Belcher get elected to the powerful office of state lands commissioner? Her strategy was to radically alter the political landscape by creating a broad new constituency for state lands. She began with the belief that

> *enough people in the state were environmentalists and were concerned about the environment that if I could get the message out to them…I could win. I wasn't going to get the money to go on TV and do that, so I looked around for alternatives and decided to see if I could get the endorsement of every group I had ever worked with—and being on [the] Appropriations [Committee]*

you work with a lot…I just made a huge list of people and I said, OK, the way we are going to do this is we are going to get all these groups to endorse me and then we are going to ask them to publicize the endorsement.

Aside from the state's environmental groups, Belcher approached community mental health groups, the Washington Education Association, school nurses and women's groups, among others. She managed to convince women particularly that they should want pro-choice people in state offices (her opponent was anti-choice).

Wherever I could [with groups I met], *I made a connection to the office. So with fire fighters I said, "You know DNR is a firefighting agency that is responsible for all the wildfires on nonfederal lands so they ought to be working closely with you guys on how we fight fires"…well that was music to their ears, they thought that was fantastic. So we put together that kind of an effort. I went all over the state. I went to places a candidate had never been and talked to groups and picked up four and five votes here and there, ten or twelve votes somewhere else, and surprised the heck out of everybody.*

In a few months she had formed a new constituency large enough to defeat the most powerful industry in Washington State.

Belcher's election rocked DNR to its core. Though she had been chair of the House Natural Resources Committee for many years, she was considered an unknown entity by DNR staff—an indication of how independent and self-directed the department had become in pursuit of its logging agenda. Not to mention its pervasive "old boys' club" atmosphere. In the DNR, only the clerical employees were women. Of her opening days, Belcher remembered:

The first week that I was in the building, somebody went into the men's room and put up signs saying, "Will the last white male living in DNR please put the toilet seat down." Somebody brought it to me and said, "Have you seen [this]?" "No, I don't go into the men's room very often, so I haven't seen it." "We found them in all the men's rooms." It just shows you how threatened people were. They thought that I was going to do something to get rid of all of them. So I took those with me to staff meetings. "I'm not here to get rid of all you men. I couldn't if I wanted to. [But I] don't want to. I need your expertise. I am not a forester. I don't know what you think and how you do it." It took me a long time to win over a lot of people.

Jennifer Belcher. *Provided by Jennifer Belcher.*

The most serious challenge came from her top staff: thirteen division chiefs. They were uniformly hostile and stonewalled her efforts to manage the department. Said Belcher:

> When I first came in, the department was in not very good shape. They had budget problems. They had management problems. I went to the head of the financial division who kept track of the whole 400 million dollars that that agency spends every two years and the 300 million dollars it makes every year—pretty important bits of information.
>
> I went to the Finance Division manager and I said, "I'd like to see a copy of the financial reports." He hemmed and hawed and said, "Which reports do you want to see?" I said, "I don't know, just whatever you generate for executive management. I'd like to see those reports." He said, "Well, if you tell me specifically what you want, I can run a report." I said, "No, no, I don't want anything extra. I just want to see what you've been giving the executive management team for the last twelve years."
>
> He hemmed and hawed again and said, "Well, the exec doesn't get financial reports." I said, "Nobody at the executive level gets regular monthly financial reports?" He said, "No." I said, "Who gets them?" He said that the people at the next level down get the reports.

So it appeared that Commissioner Boyle had delegated all his authority to thirteen division managers! He gave them hiring authority, firing authority, spending authority and, according to this man, nobody up top paid any attention until something went wrong. What had happened was that each of these thirteen people had developed their own fiefdom. They had money, and they spent it on whatever they wanted.

Next, the new lands commissioner found there was a $39 million hole in the Common School fund part of the state's budget. The deficit was a direct result of overharvesting old-growth trees on the Olympic Peninsula. The timber sales had dropped in half. The department was going into the hole fast, and Belcher needed to know from the division managers where the money was going:

"I would like to see your management reports. I'd like to know what you've spent on printing, what you've spent on travel, spent on business." They were all incensed. One of them said to me, "You are micro-managing. You have no business knowing that." I said, "Hello, let me introduce myself. I am the Commissioner of Public Lands. I just got elected and I can see anything I want to see."…They were horribly resentful, as anybody would be because they had been in charge of spending that money forever. They didn't want anybody else to know what they had.

Difficult as the department was, the timber industry was a greater enemy. In Belcher's words:

The first year I was there, the timber mill owners hired a guy, a public relations consultant, to do a $100,000 campaign against what I was trying to do. They didn't know what I was trying to do. They didn't care what I was trying to do, but they knew they weren't going to like it. So they paid this guy $100,000 to put out a campaign that says that I am screwing the state over. Of course, we had to try and counter that.

Throughout my career I had worked with many lobbyists, on all sides of many difficult issues, and for the most part, I've always found lobbyists to be credible, and generally easy to work with. The exception to that are the timber lobbyists. They have generally been very difficult to work with, and it's often their way or not at all.

Despite continued opposition from the timber industry and its lobbyists, Belcher was elected to a second term in 1996. She had changed the political landscape from that of 1957, in which a former logger and schoolteacher was elected because no one else ran, to that of 1992 and 1996, when everybody cared who ran DNR.

Belcher sees as her most important legacy the creation of the State Lands Habitat Conservation Plan (State Lands HCP). The vision for this long-term contract (fifty to one hundred years) between the state and federal government was to allow timber harvesting, as required by the trust agreements, while also providing for the continued existence of endangered species, such as owls and salmon. It guides management of approximately 1.8 million acres of forested state trust lands within the range of the northern spotted owl. The plan, proposed in 1996, stirred a sharp conflict with the state lands trustees.[140] Dan Evans, former senator and governor and then UW regent, complained it did not "maximize the income from trust lands." Despite this opposition, the final HCP for Trust Lands was approved in 1997.

The State Lands HCP was also controversial with environmentalists, who believed it was an easy way for private owners and the trusts to get around

Olympic National Park. *Art Wolfe.*

the Endangered Species Act. It did give more leeway to cut old-growth trees, many of the assumptions were flawed and the amount of habitat allowed for owls was underestimated. Still, on balance, Belcher thought this plan worth the risk.

BELCHER AND GOLDE: LEGACY IN STATE FORESTS

Environmentalists have needed patience and power in their striving to protect habitat and wildlife on state lands. The patience came from volunteers, and the power came from legislation and public outrage at the destruction caused by overcutting. They developed the skills to navigate myriad regulations and laws as well as the politics surrounding the issue. These skills helped to counterbalance the economic power of Weyerhaeuser and the other timber giants and the institutional power of the state trusts.

After more than three decades of negotiation, court decisions, invoking of national and state laws, Jennifer Belcher's eight years in office and citizen campaigns, state management of Washington forests had been revolutionized. The philosophy and personnel of the Department of Natural Resources had fundamentally changed. While timber interests were still influential and battles over ancient forestlands continued, the generally agreed upon goal now was to sustain state lands for future generations. Ecological health became the baseline, not ensuring timber profits.

6

CLEANING UP TOXIC WASHINGTON

JOLENE UNSOELD, SHERI TONN AND CHRISTINE GREGOIRE

T welve of the thirteen major rivers flowing into Puget Sound were ideal sites for industry in Washington State. Pulp mills lined the Puyallup River that emptied into Commencement Bay. Shipbuilding and leather-tanning industries were located along the Duwamish River. Log-exporting and lumber mills edged the Snohomish River Estuary and Grays Harbor. Aluminum smelters and oil refineries set up shop at various spots around the sound.[141] The result of over seventy years of heedless industrial development was a massive toxic legacy; only the Nisqually River and its delta remained relatively pristine. To the south, the Columbia River was subject to pollution of a different sort: radioactive contamination from processing plutonium at the Hanford Nuclear Reservation.

Three women were instrumental in what became successful efforts to clean up toxic waste in the Puget Sound region as well as at Hanford. State legislator and dedicated activist Jolene Unsoeld spearheaded passage of the Model Toxic Cleanup Act (MTCA). Sheri Tonn, a scientist, formed the important advocacy group Citizens for a Healthy Bay, and Christine Gregoire, while head of Washington's Department of Ecology, negotiated the Hanford cleanup.

Washington's Toxic Legacy

In January 1943, Hanford had been selected as the site for a facility to process plutonium, an essential ingredient in the nation's clandestine effort to develop an atomic bomb.[142] Two years later, the facility encompassed 560 square miles, including 554 buildings, 3 reactors and 64 underground, high-level waste storage tanks. In the first postwar decade, more reactors and 113 more storage tanks for radioactive waste were built. By the mid-1960s, the Hanford facility was in decline as a military facility but continued to produce plutonium until 1971.[143]

Radioactive gases were released to the atmosphere, contaminated water was discharged to the Columbia River, noxious liquids were dumped into the soil and highly radioactive waste was pumped into tanks, 84 percent of which had only a single rather than a double shell. By 1980, the soil and groundwater beneath Hanford contained an estimated 1.8 million curies of radioactivity and 100,000 to 300,000 tons of chemicals.[144]

Huge as that was, it was but a fraction of the amount of nonradioactive pollution that had been released into Washington's air, water and soil from a wide array of sources since the 1880s. Shipbuilding waste included glue, paint and solvents; from leather-tanning came chromium and sulfides; from aluminum smelters came cyanide and fluoride; from oil refineries came oil emulsion solids; and from pulp and paper mills came fibrous materials or organic solids, which result in oxygen depletion in waterways when digested by organisms. In the 1940s, two pulp mills in Grays Harbor discharged so much waste into the harbor that fish, including salmon, suffocated before they could move upstream into the Chehalis River. Around Commencement Bay, Asarco's copper smelter's air emissions combined with discharges from aluminum and pulp operations to create the decades-long stench nicknamed the "Aroma of Tacoma."[145]

By 1975, toxic waste sites were on the radar of the Environmental Protection Agency (EPA), which had already documented four hundred hazardous waste disaster sites around the country. A year later, the Resource Conservation and Recovery Act (RCRA) amended an earlier federal law on toxic substances, the Toxic Substances Control Act of 1971, and established a "cradle to grave" approach: an industry that generates hazardous waste is responsible for its ultimate disposal.[146] Then, in 1979, partly in response to public outrage over chemical contamination of Love Canal in New York, Congress passed the Comprehensive Environmental Response, Compensation, and Liability Act (CERCLA)—commonly known

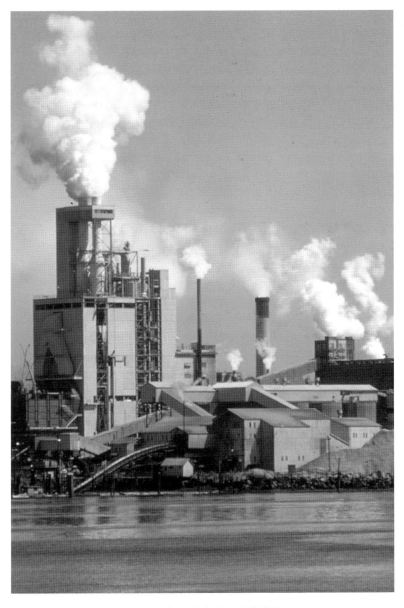

Pulp mill, Commencement Bay. *National Archives (552179).*

as Superfund. (A Superfund site is simply any land in the United States contaminated by hazardous waste and identified by the EPA as a candidate for cleanup because it poses a substantial risk to human health and/or the environment.) This law levied a tax on the chemical and petroleum industries

and provided broad federal authority to respond directly to hazardous releases that threatened public health or the environment. During the next five years, $1.6 billion was collected and deposited into a trust fund to focus on cleaning up the most dangerous locations among the tens of thousands of dangerous sites.[147]

The Superfund program includes a system of toxic site identification and prioritization, so the most dangerous sites and releases could be addressed first. The early Washington State sites nominated included two (among the largest in the nation) near Commencement Bay, two at Hanford and some major landfills throughout the state.

What about the thousands of toxic sites like abandoned gas stations, too small or ineligible for Superfund? Without appropriate legislation, the state of Washington did not have the authority or funds to clean up such sites. It was to address this gap in Washington law that Jolene Unsoeld and her environmental allies decided to draft an initiative modeled on CERCLA that would make cleanup funds available for state and local governments.

Jolene Unsoeld
and the State Superfund Legacy

Unsoeld attended Oregon State University from 1949 to 1951, became an avid mountain climber and married another (she would become the first woman to ascend Wyoming's Grand Teton via its north face).[148] She met Willi Unsoeld on a mountaineering outing. Jolene Bishoprick was a thin, energetic young woman, as high-strung as a hummingbird. She had short brownish-blonde hair and bright, darting eyes. They announced their engagement while climbing Mount St. Helens and married in 1951 on Mount Hood. Willi was a charismatic figure and enjoyed the camaraderie of the climbing culture. Friends usually surrounded him as he told jokes and stories. Jolene was a more private person, devoted to her husband.

After five years in Nepal, they moved to Olympia in the early 1970s. Not long after, in 1976, their youngest daughter died in India climbing with her father. Three years later, Willi himself died in an avalanche on Mount Rainier while leading Evergreen State College students up the mountain. "Living beyond grief is probably as hard a thing you will tackle," Unsoeld was quoted as saying. "It toughens you, which is necessary if you're going to be in this type of public service."[149]

Jolene Unsoeld. *Troy Wayrynen.*

Unsoeld spent the 1970s and early 1980s as the conscience of the Washington state legislature. Always concerned about water quality, she was among the first to question the ability of local communities to cope with ground water contamination without state funds. Her first major victory was the campaign for Initiative 276, passed in 1972, which created the Washington Public Disclosure Commission. This initiative required candidates for elective office to disclose campaign contributions. Before she was elected to the state legislature herself in 1984, she was a citizen lobbyist in support of open government, including open public meetings and open public records, and an advocate for the importance of water quality.[150] One observer described her as "a one-woman good government crusade in the state, a familiar figure striding single mindedly through the marble corridors in the state capital pursuing malefactors of power."[151]

In 1988, Seattle attorney Rod Brown recalls that Unsoeld put out a call for assistance in developing state legislation modeled on CERCLA:

"Are there any environmental lawyers out there who know anything about drafting a State Superfund law?" [she asked]...*I didn't know that much about it—at least, not as much as I would learn later. I...went down to Olympia and met with her, and before I knew it, this was my issue for the next five years, because with Jolene, it's all or nothing, you know. Jolene works harder than anyone I know* [and] *has the enthusiasm of ten people, and before you know it, you've just been sucked into this high-energy project that you just can't get out of—you don't even want to get out of it! But you couldn't* [anyway] *because Jolene is just a force of nature...*

This was literally Jolene and Boeing [as well as big oil, Weyerhaeuser and asphalt manufacturers] *behind closed doors negotiating over a Superfund bill, and it was Boeing—it wasn't the Republican caucus in the house and the senate. It was Boeing's lawyer. He is a guy I happen to know and so that was where Jolene dragged me in and said, "You've got to come help me because it's me against Boeing."...Boeing had a lawyer from Perkins Coie...busy negotiating against this Democrat who had no staff support and very little help, and Boeing can hire all the lawyers and scientists that it could throw at it...*

On the last day of the session, we had this terrible weak compromise. They [Boeing, et al.] *had been going behind our backs lining up the votes to pass something totally worse than what we had agreed on...On the last day of the session, Boeing's supporters passed a bill at the same time they were negotiating this supposed compromise with us.*

[T]*hat's when Jolene said, "Well, they think that they've won, but I'm telling you that's just Round One. We're going to go to Round Two—there's another vote where we get to count votes, and that's with the people."*[152]

As former state representative Nancy Rust remembers:

I worked very hard on the Model Toxics Control Act—we tried to get the toxics bill through the Senate; Mike Lowry worked on it when he was chair of the Ecology Committee in the Senate. Jolene Unsoeld worked...on it when she was a member of my committee [Environmental Affairs] *in the house. And we got a bill through the house committee...We were not going to compromise any further, this was our last offer. And the business community didn't believe it when Joe King, who was Speaker, told them that that was it, and so they passed an amendment that would weaken the bill further, and I'll never forget Joe King's three famous words—"pass to rules"—and he killed the* [watered down] *bill right then.*[153]

Unsoeld, with the help of sympathetic environmentalist allies, filed the statewide Initiative I-97, a much stronger version of the toxic control bill.[154] Rod Brown said:

> *Even though she* [Jolene] *was a legislator, she was the one saying that it's not all about the legislature; there are other places to win the fight. We have a right to go to the people and get the people to do it in an initiative.*
>
> *And we did it. She ended up being the political leader of the campaign, which was very courageous, because legislators back then, even now, are afraid of alienating their fellow legislators by running an initiative…And in fact, we were, in one sense, trashing the legislature for being in Boeing's pocket.*

Unsoeld and Brown had a strong army behind them, including the president of the League of Women Voters and the Washington Public Interest Research Group staff and volunteers for the I-97 initiative to enact the Model Toxics Control Act (MTCA). One of the key players was Tacoma resident Sheri Tonn, professor of chemistry at Pacific Lutheran University. Tonn said of Unsoeld: "Jolene was…really brilliant in understanding how to use the political system. Given that I was a scientist and came from a background that's pretty hardcore chemistry, I really appreciated that she could take the technical stuff and bring it up to another level and make it more understandable on a political level. She was masterful at that."[155]

Initiative 97 passed in 1988. The final Model Toxics Control Act funded hazardous waste cleanup through a tax on the wholesale value of hazardous substances. The tax is imposed on the first in-state possessor of hazardous substances at the rate of 0.7 percent, or $7 per $1,000. Passage of the MTCA and the revenues generated by its provisions have led to the cleanup of thousands of hazardous waste sites in Washington. Of Unsoeld's work in leading the MTCA effort, Rod Brown has said:

> [S]*he aligned herself very firmly with the environmental community, which in the legislature back then wasn't always the popular thing to do. In fact, it was probably never the popular thing to do. She took a stand, and we worked like crazy and won.*
>
> *I will say, to* [Boeing's] *credit, after they lost in the initiative campaign, they came to Jolene and said, "We don't ever want to have a fight like this ever again…We promise we won't try to gut MTCA, we won't try to amend it, and we will work with you"…Jolene could show both sides. She*

could say, "I'm going to fight you. I'm going to be the general in charge of the army that's going to go to war against you." But then she could make peace with them as well.

Sheri Tonn: Citizens for a Healthy Bay

Two years after passage of the MTCA, Sheri Tonn and other Tacoma residents created Citizens for a Healthy Bay; its mission was to establish "a healthy [Commencement] bay, healthy environment, and healthy economy," in part by serving as a watchdog to the Superfund cleanup of the bay.

Commencement Bay's once extensive tide flats were filled in during the late 1800s, and five waterways were dredged to create an industrial complex for shipping and smelting. According to the EPA, the Asarco Smelter area contained metals including arsenic, cadmium, copper and lead, and the Tacoma Tar Pits were contaminated with organic and inorganic materials

Asarco smelter, July 1953. *Tacoma Public Library.*

from former on-site coal gasification plant operations and the recycling of automobiles and electrical transformers. The primary contaminants included metals, PAHs, PCBs and various volatile organic compounds (VOCs) including benzene.[156]

As a chemistry professor at Pacific Lutheran University, Tonn was at the right place at the right time to assess Commencement Bay cleanup efforts. When she moved to Tacoma in 1979, she was already an experienced environmental advocate with a passionate interest in water pollution issues. The granddaughter of Oregon farmers and loggers, she studied chemistry at Oregon State, went to graduate school at Northwestern and then continued on to postdoctoral work at the University of Minnesota, where she investigated pollution of Lake Superior by taconite mines in the region. Of her subsequent move to Tacoma, Tonn recalled: "I called up the local Sierra Club activists and said, 'Hi, I'm here, I want to get involved,' and that took about 15 minutes before somebody found something for me to do, and that was [to join the advisory committee for] the Puget Sound Air Pollution Control Agency…As time went on, I was elected to the Sierra Club Executive Committee…as well as…serving on the Superfund Citizens' Advisory Committee here in Tacoma."

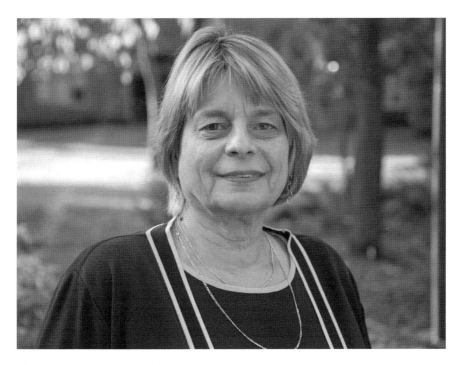

Sheri Tonn. *Pacific Lutheran University.*

Tonn worked closely with Delores Solerius, a Tacoma environmental activist interested in toxics and the Sierra Club National Toxics chair for many years. Together they published a quarterly national newsletter that covered both water-quality and toxics issues. Tonn not only kept up with scientific reports but also did research of her own on the deleterious effects of tributyltin, an ingredient in boat hull paint, on oysters. Helen Engle and Solerius were also on the circuit giving talks to Audubon and Sierra Club chapters and lobbying public officials for funds to clean up toxic waste. These citizen activists took responsibility to educate the public, which the federal agencies could not or did not do. As a local leader in the Tacoma area, Tonn also worked closely with Vim Wright, Helen Engle and, of course, Jolene Unsoeld to pass State Initiative 97 to authorize a state Superfund program.

For more than two decades, Citizens for a Healthy Bay has established itself as the "go to" organization and the central clearinghouse for information on Commencement Bay. In 1991, the St. Paul waterway beach was certified as clean, and Tacoma is gradually recapturing its waterfront. In 2008, the group purchased its own boat and christened it *The Sheri T* in honor of its founder.

CHRISTINE GREGOIRE AND THE BREACHING OF HANFORD'S WALL OF SECRECY

Because of its military mission, the Hanford Nuclear Reservation was cloaked in secrecy—accountable to no one—and the secrecy extended to releases of contaminants. In addition, to achieve maximum flexibility in waste disposal, the U.S. Department of Energy operated under what was often referred to as "the dilution solution." This meant that the amount of radioactive waste would not be measured at the source, or "point of exposure," but only around the boundaries of the entire 560 square miles. The assumption was that the environment—air, water and soil—would absorb the waste.

The emerging environmental ethic of the 1960s made a clash with the military culture at installations like Hanford inevitable. For nearly two decades, the Department of Energy and its forerunner, the Atomic Energy Commission, insisted that federal and state environmental laws did not apply to Hanford. However, in 1984, a citizens' group in Oak Ridge, Tennessee, the Legal Environmental Assistance Foundation, won a court battle based on the Resource Conservation and Recovery Act (RCRA). The ruling

Hanford Nuclear Reactor. *U.S. Department of Energy (N1D0069267)*.

mandated that RCRA regulations for proper handling, management and disposal of toxic waste did apply to waste from federal installations.

Even so, the Washington Department of Ecology could only enter the federal government's Hanford site if accompanied by EPA staff during their monitoring of National Pollution Discharge Elimination System permits, the single regulation the federal Department of Energy would abide by. During these visits, Department of Ecology staff were admitted only as a courtesy— even though the Hanford reservation was an ominous threat to the Columbia River and the residents and officials of the state of Washington had been told next to nothing about the waste created during the previous forty-five years. But in 1987, when Congress gave states the authority to regulate the cleanup of nuclear waste, the balance of power shifted dramatically.[157]

Christine Gregoire, who was then director of the Department of Ecology, recalled how she convinced the Department of Energy to negotiate with the state: "I began the process of making sure folks in [Ecology] were aggressively trying to get as much information as possible, and I built that

up for a while until I felt comfortable [that] I could put what I thought was significant pressure on the Department of Energy to either continue this shroud of secrecy or, as I was about to suggest to them, come to the table and see if we couldn't get it resolved short of litigation."[158]

Citizens' groups viewed litigation as the only way to shut down Hanford, given the culture of secrecy surrounding the facility and its hazardous waste. However, in Gregoire's view, a court fight would create a "public circus": "you can [often] get a whole lot more accomplished at the negotiation table. In retrospect, I have no question in my mind that was true in this instance."

The right people and personalities came to the table. Everybody had something to gain and something to lose. A major handicap to waste cleanup was that records were almost nonexistent. Even so, Gregoire was determined that "we were going to have a milestone [a measurable result] on everything we could think of." These milestones were not intended to be sacrosanct. She pledged to amend milestones when technology problems intervened. The Department of Energy trusted this assurance and a strong partnership formed among the three parties. For Gregoire, the absolute goal was "cleanup": "That's why it's called the Cleanup Agreement. And cleanup meant they've got to remove the waste."[159]

Jay Manning, later director of the Department of Ecology, and Roger Stanley were the Department of Ecology's lead negotiators. In 2007, Manning recalled the nineteen-month process that led to the Tri-Party Agreement:

We spent two years shuttling back and forth to Tri-Cities (Pasco, Kenniwick, Richland) and then coming over here to Olympia, and between us [the state Department of Ecology] *and EPA and U.S. DOE* [Department of Energy], *we finally got a draft agreement. And a number of times…*[Gregoire] *was very involved. We were briefing her on a daily, weekly basis, and she'd come in and help us get unstuck when things got stuck…It would not have happened without her. And we ended up getting an agreement, and it remains a huge, huge thing that we have that agreement in place…*

That [nuclear] *mission has stopped; they're not doing any of that. The whole mission now is cleanup. They're spending $2 billion a year out there. We never, ever in our wildest dreams thought that we could force the federal government to spend that kind of money at Hanford.*

A lot of the really high-risk facilities out there have been cleaned up and [are] *under control. The big exception are the tanks, and we all knew from the get-go that those 177 tanks and the 65 million gallons of high-level*

Christine Gregoire. *Washington State Governor's Office.*

*nuclear waste in those tanks…was going to be the hardest, and in fact, it's
turning out to be the hardest.*[160]

Gregoire served as Washington State's attorney general from 1993 to 2005,
winning a landmark ruling in the U.S. Supreme Court that transformed
western water law: Water must remain in the river to satisfy other laws,
especially the requirement, under the 1972 Clean Water Act, that rivers
should be "fishable, swimmable, drinkable."

In 2004, Gregoire ran successfully for governor and was reelected for a
second term in 2008. As governor, she did much to protect Washington's
natural heritage. Of her many initiatives, two stand out for their toxin-
related environmental achievements:

1. The Puget Sound Partnership, established in 2007 to protect,
 restore and prevent pollution in Puget Sound. To date, more than
 six hundred projects have been completed or are underway, creating
 more than fifteen thousand direct and indirect jobs in region.
2. The Washington Shellfish Initiative, an agreement among federal
 and state government, tribes and the shellfish industry to restore
 and expand Washington's shellfish resources to promote clean-water
 commerce and create family-wage jobs.[161]

These are but three of the many women who have played a role in overcoming the state's toxic legacy. Betty Tabbutt, for example, led the Nuclear Waste Advisory Council, and Kathy Fletcher made enormous contributions to the cleanup of Puget Sound through her leadership on the Puget Sound Water Quality Authority and with People for Puget Sound, which she established in 1991 to mobilize citizen support for the cleanup. The energy of a small corps of women, including Liz Tennant, Betty Tabbutt, Doris Solerius and Pam Crocker-Davis, was also instrumental in establishing the Washington Toxics Coalition, which helped secure for Washington the strongest standards in the nation restricting toxic chemicals in children's products and securing a state ban on the hormone-disrupting chemical bisphenol A (BPA) in baby bottles, sippy cups and sports bottles.[162]

As a result of such concerted efforts, Washington is a lot cleaner now, and programs to eliminate toxins from the Washington environment continue to expand with strong public support.

Winning the Thirty-Year Struggle for Nisqually River Delta

By the early 1960s, the Nisqually Delta just south of Tacoma was the sole relatively untouched river system left from the mad rush to exploit Washington State's natural resources in the twentieth century. By that time, the other twelve major rivers that flow into Puget Sound had already fallen prey to industrialization, as we saw in Chapter 6. Saving the last surviving natural river and its delta from a similar fate became a community effort, beginning in the late 1950s. In the ensuing decades, many of Washington's women conservation leaders committed themselves to preserving the Nisqually, among them Margaret McKenny, Flo Brodie, Joan Thomas, Helen Engle, Jennifer Belcher, Karen Fraser, Janet Dawes and Mary Martin.

First Alarms: Margaret McKenny

Among the first to articulate the need for the Nisqually's protection was Margaret McKenny, an esteemed Tacoma botanist and preservationist. In 1966, she formed the Washington Citizens Committee for Outdoor Resources and began seeking support to save the delta through "acquisition and preservation [of the delta] for the public in its natural state."[163]

McKenny's citizens' committee was forming as interest in putting the Nisqually region to industrial use was intensifying. In 1964, the City of Seattle, for example, explored the possibility of locating a

Margaret McKenny. *Nisqually Delta Association.*

garbage dump in the delta; the following year, the Port of Tacoma considered dredging the delta to create a deepwater harbor. Of that plan, Helen Engle, an early South Sound activist, commented:

[E]*verybody got in on that one, the League of Women Voters…Joan Thomas, I believe, was president of the State League at that time…I bet I led a hundred field trips down there to convince people what an important threat that was going to be for that river, which already had hydro power dams in it, but no industrial development or the usual things that happen to rivers…*[T]*he Port of Tacoma was discouraged and driven away, and then* [came] *Weyerhaeuser. In the meantime, we*

started working on getting it…refuge status. We ran bills through every
session of the legislature.[164]

We called them the "Nisqually bills" because it seemed like they were
always with us, never passed, and we'd just rewrite them the next session…
The Washington State Legislature never did pass any of our bills.[165]

A more encompassing strategy emerged from Governor Dan Evans's office in 1971. Jennifer Belcher was then working in the governor's office, as secretary to the urban planner Richard Slavin, so she had an inside perspective: "He [Slavin] got very interested in the Nisqually River Delta, and he worked with Margaret McKenny and the tribes and other[s]… He convinced Governor Evans to establish a Task Force…to put together a plan. 'From the mountains to the sea' it was called, a plan for the management of that river system [from its source on Mount Rainier to its mouth on Puget Sound]."[166]

The first plan, the Nisqually River Plan: Rainier to the Nisqually Delta, was issued in 1972. Although subsequently supported by both Governors Ray and Spellman, that version was never translated into legislation. More than a decade later, in 1985, it would reappear in the form of a very different Nisqually Bill that authorized the establishment of a Nisqually River Task Force.

FLO BRODIE: THE NISQUALLY DELTA ASSOCIATION

The plans for port development on the Nisqually energized conservationists led by Flo Brodie, McKenny's hand-picked successor who formed the Nisqually Delta Association (NDA) in 1970, a woman of great independence, as Janet Dawes remembered: "Perhaps a good example of Flo's individuality was her ownership of one share of Weyerhaeuser. She never cashed the dividend checks despite Weyerhaeuser's pleading to buy out smallholdings shareholders, but used them to paper her bathroom. She also hung her environmental awards in there."

Gordon Alcorn and Dixy Lee Ray, head of the Pacific Science Center, completed a study confirming the delta's biological richness as a stopover on the Pacific Flyway between the Skagit and Columbia Rivers, supporting two hundred species of birds, and that its waters were rated AA, the highest rating for purity.[167]

Flo Brodie. *Nisqually Delta Association.*

Brodie and the NDA campaigned for the creation of a wildlife refuge. Again, Janet Dawes commented:

> [This was] *early in the time of environmental activism. There were not so many organizations competing for memberships, and the issues that the delta presented stood out so plainly as unfair, that many people over a wide area came to be helpful, even if it only meant writing a check. While it was unfortunate that I-5 borders the Nisqually Delta, it has made the area very visible and recognizable to many, many people. Saving that versus enabling further industrial development there makes a dramatic picture.*

In 1973, Congress passed a bill to establish a wildlife refuge, and in the following year, the U.S. Fish and Wildlife Department purchased the Brown Farm to create the Nisqually National Wildlife Refuge. Much remained to be done to save the delta, however, as Weyerhaeuser still planned a major shipping port nearby that would cause great disruption to the delta and its wildlife.

Brodie recruited Mary Martin into the campaign, Martin remembers:

I loved Flo. I met Flo when I was in graduate school the first time, and working on a thesis—we were studying grass-roots organizations. And so I called up and made an appointment with her, and well, I was hooked.

Well, her house reminded me of that movie [Reds]...the low ceilings, and everything kind of dark and very intellectual, and books, books, books, all through her house. Her yard on Water Street in downtown Olympia, where everything [else] was so well manicured, hers was like walking into a forest. It was always cool in her yard, because she had all those natural plants, so it kept the place dark and cool, and just so interesting...on the back deck, she had two flowering plants next to each other, and one liked bumblebees and the other liked honeybees, or other bees, and so she would get a kick out of it, because then when they'd run into each other, they'd fight.

I could tell I was just the pigeon that she was looking for. I felt like running from the house. But then she kept calling, "Hi, how are you, just wondering..." One day she called and invited me to a Nisqually Delta Association meeting. A friend of mine from Anderson Island, Rick Anderson, was there, and he invited me on the board. I was looking for something to do.[168]

JOAN THOMAS AND THE 1972 SHORELINE MANAGEMENT ACT

In 1970, a wave of public concern about the despoliation of the state's environment led Governor Evans to call a special legislative session during which many environmental laws were enacted. Then, in 1972, the Shoreline Management Act was passed with the strong backing of many Nisqually activists. Joan Thomas, one of the drafters of the act, was instrumental in including protection for "Shorelines of Statewide Significance," a special category of shorelines (marine, river and lake) recognized as in need of protection and with six preferred uses. The first four of these were to

recognize and protect the state interest, preserve the natural character of the shoreline, result in long-term over short-term benefit and protect the resources and ecology of the shoreline. The act also required all jurisdictions to prepare a management plan consistent with the act, to be approved by the state's Department of Ecology, and it established a hearings board to consider appeals of these plans.

The Nisqually Delta was one of the first named as a shoreline of statewide significance, but that, in itself, offered no magic bullet of protection. There was a loophole. The City of DuPont, for example, prepared a shoreline management plan in 1974 that designated most of the Nisqually shoreline as "conservancy" with a caveat, grandfathering in 3,110 linear feet around the old Atlas Powder dock (just half a mile from the wildlife refuge) for urban development—also known as an "urban window." The plan was submitted to the Department of Ecology and at first rejected but then, in 1975, given qualified approval. The department's letter was a masterpiece of bureaucratic doubletalk: it granted approval of the plan but, at the same time, strongly cautioned against its implementation.[169]

In 1976, Weyerhaeuser—the state's second-largest employer and wielder of great political influence—purchased the old DuPont property, including the Atlas Powder Wharf, and announced plans to construct a major forest products industrial complex with deepwater shipping facility, which required getting a "conditional use permit" from the City of DuPont. This set in motion a David-and-Goliath battle between the NDA and the timber giant. The city ignored its own permit requirements and approved Weyerhaeuser's log port. The NDA immediately challenged the permit, but in 1978, the Shorelines Hearings Board granted a conditional use permit by adding a word to reinterpret "no adverse impact" as "no reasonable adverse impact." Apparently the word "reasonable" included a major port facility for Weyerhaeuser next door to important wildlife habitat. The "urban window" remained open.

The struggle with Weyerhaeuser intensified, as Helen Engle related:

One day a high management guy [from Weyerhaeuser] *called me up, and he said, "I'd like to talk to you one-on-one, just off the record." He came out and we sat right out there* [at her home on University Place] *on a summer afternoon, and he said, "I'd like to know exactly where your line in the sand is, what you will not compromise." Well, luckily, I had 24-hour notice that he was going to come talk to me about that, so I got to talk to a couple other people, and we all agreed on where that line in the sand was. I told him what it was: "Respect the refuge and stay away from*

any facilities on that shoreline. The shoreline is off limits." Another was to respect the history. That's the most historic place in the Northwest.

Environmentalists rushed to aid the NDA and helped establish a beachhead of their own on the shoreline. According to Engle:

Nisqually Delta Association, Tahoma Audubon Society, and Seattle Audubon bought five acres of land in order to have [legal] *standing. We bought five acres out in the mud flats, and Bill Drury, president of Tahoma Audubon at the time, took a canoe and went out there, tramped out to an old piece of uprooted driftwood out there. We got photos taken and generated big publicity.*

In June 1982, environmentalists filed suit in Washington Superior Court contesting DuPont's permit. They lost, and lost again on appeal, but were able to claim a partial victory: the court restricted the development to only the export of logs, not the larger complex originally proposed. But Weyerhaeuser had won the battle while losing the war. The timber market had changed and the log port was never built, although a housing development close to the tiny city of DuPont was.

JANET DAWES, MARY MARTIN AND THE LONE STAR GRAVEL PROPOSAL

Janet Dawes and Mary Martin went on to work in tandem to save the Nisqually Delta from threatened development. They were an ideal combination—quiet and determined Janet Dawes and Mary Martin, NDA's public face, outgoing and comfortable in that role. In Martin's view, "Janet was really the impetus behind it…She didn't like to speak in public, she didn't like to do all those kinds of things, which I'm very comfortable doing, but she was the backbone, the brains, and she had the computer."

Upon first meeting Janet Dawes, you think, "She seems very sweet." Her now silver hair, twinkling eyes and conservative dress bespeak of someone having tea in a drawing room. Janet is smart, tenacious, and willing to go on the attack when needed, however. As described by attorney David Bricklin, "She was a tiger in sheep's clothes."[170]

The Nisqually River had caught Janet's imagination in her childhood, and she returned to the struggle to save the Delta in the early 1970s after

years away in Texas and Canada. Unlike Dawes, Mary Martin was not a native of the Nisqually area. She appeared on the scene in the early 1980s when she and her family moved to a house above the Nisqually Wildlife Refuge: "I moved down here from Ballard, which is an industrial port, and I wasn't at all upset to hear that there was going to be an international port right across the way until I sat there for a little while. [I thought,] 'This looks very special. I don't think it should get ruined.'"

By the mid-1980s, the mood had begun to shift in the state legislature in conservation's favor. In 1985, the "Nisqually bill" (Engrossed Substitute House Bill 323), sponsored by state representatives Belcher, Unsoeld, Allen, Rust, Locke, P. King, Jacobsen, Fisher, Brekke and Day—more than half of them women—finally passed, actively supported by environmental organizations and the League of Women Voters. The bill directed the Department of Ecology to form a new Nisqually River Task Force to develop a new plan. Membership of the task force was balanced and broad; it included Mary Martin, president, NDA; Lee Carpenter, vice-president, Washington League of Women Voters; Helen Engle, director, National Audubon Society; Stan Cecil, president, Washington Environmental Council; and Bill Frank Jr., fisheries manager, Nisqually Indian tribe. One of the most influential participants in behalf of the river's health was the Nisqually Indian tribe. The fruit of the task force's efforts, the Nisqually River Management Plan, was adopted by the legislature in 1987 and established the Nisqually River Council to implement this plan.

In 1987, the persistent and powerful Weyerhaeuser Corporation initiated another attempt to use the dock for industrial purposes, this time by leasing it to Lone Star Industries. Two years later, Lone Star Industries, eventually renamed Glacier Northwest, announced its plans for a twenty-year 450-acre gravel mining operation. The plans included a conveyer system to move the gravel from the bluff to the dock below. The dock, of course, would have to be enlarged and modernized from its then dilapidated state. The system would operate around the clock with powerful lights for twenty-four-hour visibility. Imagine the incessant crashing and banging as gravel was dumped onto a conveyer belt and then loaded into a steel vessel only a half mile from the refuge.

The debate in the city of DuPont over a development permit was intense. The city council wanted to approve the project. Some key women in the town, alerted by Dawes and other members of the NDA, expressed reservations, but as Martin explained, that did not turn the tide: "[The City of] DuPont had been bought and paid for by Weyerhaeuser Corporation many years ago, and now they needed the money for their infrastructure… sewers and roads. [T]here was a lot of controversy about how this would

change the town with the trucks going through…but it became pretty clear that we weren't going to be able to prevent it."

A project of this magnitude had to conform to the National Environmental Policy Act (NEPA), however, and required a full environmental impact statement (EIS). The first step in this process is a public Scoping Hearing to review the items to be covered in the EIS. At the hearing, and in the EIS, Lone Star claimed that noise and disruption would be minimal, but everyone knew that a sneeze on the old dock would echo throughout the estuary. At this point, the NDA board was able to locate a courageous and objective noise consultant in Seattle to make a second analysis that, not surprisingly, contradicted the results of Lone Star's study.[171]

The NDA challenged the completed EIS before the Shorelines Hearing Board on multiple scientific grounds, one being the noise analysis. This time, the Department of Ecology, led by its director at the time, Mary Riveland, denied Lone Star's permit, which sent the case back to the Shoreline Hearings Board.[172]

The Shoreline Hearings Board instructed the participants to negotiate an agreement. A potential compromise was reached: the dock and gravel pit would be sited further from the refuge and the urban window designation eliminated. But Dawes decided to introduce an additional issue: mitigation money for land purchases to minimize the impacts of all the development. She was pleasantly surprised when this request did not deep-six the negotiations. The NDA got a goodly settlement for land purchases that might not have been forthcoming had it not asked.

Initially, the City of DuPont refused to sign the agreement. Dawes and others from the NDA focused on persuading the women of DuPont. They described the potential impact of a port in this location: trucks constantly moving back and forth through the city, noise twenty-four hours a day. At the last minute, DuPont agreed to sign.

The editorial in the *Seattle Times* on August 29, 1994, declared, "Peace on the Nisqually": "Credit goes to the Nisqually Delta Association and local environmental watchdog Janet Dawes, and to the two companies for their willingness to listen and look for common ground. But perhaps the key player was state Department of Ecology Director Mary Riveland, who insisted on protecting that valuable shoreline."[173]

In 2003, the Nisqually River Council recognized that the planning process must incorporate the entire watershed within an ecosystem approach. The new scheme, the Nisqually Watershed Stewardship Plan, was adopted in 2005 by the legislature. The goal of the broadened plan was "to ensure that the work of the past two decades to preserve and restore the watershed

Nisqually River Delta. *Art Wolfe.*

could be sustained in the future…to develop a place where people can earn a living, be part of a community, and enhance the environment."[174] The plan acknowledged the efforts of two women in particular, state representative Jennifer Belcher, who introduced the legislation that created the Nisqually River Council, and state senator Karen Fraser, among the visionaries who created the Nisqually River Management Plan.[175]

The key to the ultimate restoration of the delta, the Nisqually Land Trust, was formed in 1988, with funds from the settlement with Lone Star Gravel. The trust acquires and manages critical lands to permanently protect the water, wildlife, natural areas and scenic vistas of the watershed. The organization's first president, George Walters, who was also involved in the preservation fight, is still leading the restoration effort, working closely with the Nisqually tribe. The trust and its conservation partners so far have been able to protect much of the salmon-rich shoreline and some of the surrounding lands.[176]

Women conservationists, and the men who joined them, were instrumental in winning this long battle for the Nisqually delta. Their perseverance in pursuit of a goal, their interest in building a team and network of support and, finally, their civility and empathy over the years were all important ingredients in this effort. The dream of preservation originally expressed by Mary McKinney was finally being realized.

Moving from the Backseat to the Front Seat

Women have a remarkable track record in conserving one of Washington's great treasures—its natural heritage of clean air, sustainable forests and clean water. Early in the twentieth century, female civic activists such as Emily Haig and Polly Dyer mobilized to save ancient forests and wilderness areas. Later, Sheri Tonn and Jolene Unsoeld successfully led the cleanup of pollution and toxic waste sites, and six female legislators—the Steel Magnolias—led an effort to ensure that Washington's natural heritage would be considered during a period of rampant growth. These were just a few of the challenges taken up by women, and their male colleagues, throughout the twentieth century that continue today.

Their achievements are revealed in our healthy forests, clean rivers and well-managed urban development: a foundation of environmental well-being built in no small part by Washington's mothers of nature. But for the participation and leadership of women, many major Washington State conservation victories would almost certainly not have happened, among them:

- 1971 Shoreline Management Act
- Olympic National Park, including timbered river valleys
- reduced cutting of Washington's ancient forests
- North Cascades National Park
- Washington Model Toxics Control Act
- cleanup of toxics in Commencement Bay
- preservation of the Nisqually Delta

- 1984 Washington Wilderness Act
- emergence of the environmental community as a political force
- Growth Management Acts

BACKSEAT BEGINNINGS

Washington women learned early on that you did not have to be in a position of authority to lead. The women's suffrage movement and the League of Women Voters prepared them to analyze and address public issues. Emily Haig learned how to organize people in the Seattle Garden Club and as president of the Washington Parent Teacher Association; Helen Engle first ventured into local politics as a volunteer in the Pierce County League of Women Voters.

Joan Thomas, Vim Wright, Hazel Wolf, Harriet Bullitt and Estella Leopold devoted their lives to building the environmental community. None sought elective office. Most started their work before elected office was a viable option for women, when the culturally appropriate behavior for women was to sit quietly and allow men to step forward into the limelight. But they were leaders in their own way, and together they gave a total of four hundred years' worth of work to save the natural environment in Washington State. No wonder they have been able to accomplish so much. Women did so well in the backseat it was sometimes hard to tell who was driving. These women learned that leadership is a state of mind, not simply a position or formal role.

To the Political Front Seat

These and many other women excelled at using informal power systems and building civic organizations, most often as "professional" volunteers. The next step was to enter formal power systems dominated by men. Direct election by the people allowed women to make an end run around the "good old boys" network. Women environmentalists began to trickle into the state legislature, and the trickle became a stream.

From 1913, when the first woman was elected to the Washington state legislature, the number of women in the legislature rose to thirteen in 1943 but didn't begin to increase again until the 1970s, to a high of twenty-seven in 1979. By 1992, though, fifty-eight women were elected to the legislature,

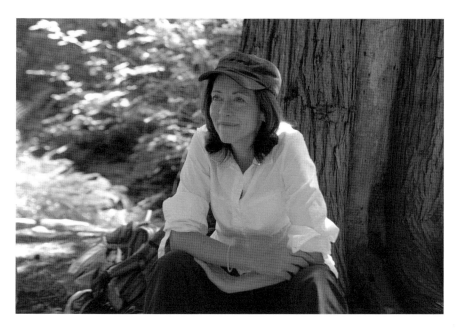

Senator Maria Cantwell hiking in the Stehekin Wilderness. *From the Office of Senator Cantwell.*

and one, Patty Murray, to the U.S. Senate—under the slogan "A Mom in tennis shoes."[177] That year, too, Jennifer Belcher became the first woman to be elected lands commissioner in the state and Christine Gregoire became state attorney general.

By 1999, Washington had both the highest number and the highest percentage of women in a state legislature: sixty women, 40.8 percent of the total, though these numbers have subsequently dropped off to forty-seven women, 31.0 percent of the total, in 2012. In 2000, Maria Cantwell ran a successful campaign for the U.S. Senate, and four years later, Gregoire was elected governor in a dramatically close race, beating her opponent by just 158 votes after two recounts.[178]

WORKING WOMEN AND THE ENVIRONMENTAL MOVEMENT

The environmental movement has changed considerably over the past fifty years. Now more married women go out to work and have less time to volunteer. As the environmental movement has switched from primary

reliance on volunteer labor to more reliance on hired staff, it has encountered some of the same problems as the corporate world: accommodating women as leaders.

A 2010 review of sixty nonprofit environmental advocacy groups in Washington State found that women account for 57 percent of their total workforce—slightly higher than the national average (47 percent). If women had equal access to leadership roles, they should also account for more than half the leadership roles. But women held only 41 percent of the leadership positions (as shown by job title) in these groups. Women in Washington environmental groups are doing better compared with the nation as a whole, where only 34 percent of managers are women, but in state natural resource agencies, they are doing worse: only 29 percent of managers are women.[179]

In the world of work, in corporations, nonprofit organizations or elected bodies, women still typically have to deal with entrenched, historically male-dominated cultures and bureaucracies. In this world, the pathway to success can be somewhat mysterious, with arcane rules and expectations and a well-established old boys' network. Although many women have climbed the corporate, nonprofit and agency ladders to the top, and some have occasionally been able to form their own organizations, the value systems of corporate America and government bureaucracy are deeply entrenched. Changing the cultures of large organizations is difficult and very, very slow. Nevertheless, societal norms are changing, a recent example of which is President Obama's appointment of Washington State native Sally Jewel as secretary of the interior in April 2013.

EMERGING WASHINGTON LEADERS, EMERGING ISSUES

Along with other changes, perceptions of environmental protection in recent decades have morphed from what to some seemed an esoteric concern for wilderness and wild places to an increased concern for people and their lives and the need to maintain a healthy environment for our families. Kathy Fletcher, recently retired executive director of People for Puget Sound, commented: "Our population continues to grow, so the real environmental issue is how we come to terms with living in a place that we also want to be healthy. So urban issues, restoration of damaged areas, human health connections with environmental quality, these are the things that I think are 'the now' of the environmental movement much more than previously."[180]

Joan Crooks. *Washington Environmental Council.*

This century's environmental challenges, such as managing climate change, controlling new generations of toxic substances and ensuring adequate clean water for all, require the same virtues the women featured in this book displayed: perseverance, commitment to a goal and willingness to reach across individual differences for the common good.

Fortunately, a new generation of Washington female leaders is emerging. Many among them have learned from the work of the elder stateswomen and work together with a sense of a shared history and future.

Joan Crooks, for example, is an imaginative protégée of more than one of Washington's elder stateswomen. Executive director of the Washington Environmental Council (WEC) since 1995, Joan brought a fresh perspective to the then thirty-year-old organization and encouraged concentration on a limited number of objectives instead of the group's earlier scattershot approach of responding to crises as they occurred. She built close relationships within the environmental community and beyond it to present a united front to the state legislature on carefully selected issues, among them clean energy, low-emission cars and green buildings. "I may not go out front and charge

ahead," she says of herself. "I work to bring along and push people toward what I think are the important goals for the community as a whole."[181]

Martha Kongsgaard, a lawyer by training and former WEC board member, nurtures a strong sense of community and connects environmental needs to social issues, such as healthcare, allowing her to move easily among many different groups. In 2007, Governor Gregoire appointed her to serve on the governing body of the Puget Sound Partnership, and in 2012, she was appointed chair, replacing William Ruckelshaus. Most of the worst industrial sources of pollution in Puget Sound have been cleaned up. Now, the major task is to orchestrate region-wide cooperation to reduce the pollution from storm water runoff that pours into Puget Sound from the highways and urban development that surround it. Martha believes that being a woman helps in her work: "I think that there is a thread that runs through women that maybe originates out of some connection to—maybe it sounds cornball to say—connection to the greater good. I think mothers, women, are just more naturally outward looking, other-people-looking, common-good oriented."[182]

Joan Crooks and Martha Kongsgaard are just two of the emerging leaders. There are many more, including, for example, the new director of the Washington Department of Ecology, Maia D. Bellon, a talented protégé

Martha Kongsgaard. *Puget Sound Partnership.*

of Christine Gregoire. A Mescalero Apache and daughter of the Chehalis tribe's executive director, she is perhaps the first Native American to serve in a cabinet-level position. And there is Patti Goldman, another Washington woman who has risen to prominence in recent years as the vice-president for litigation for EarthJustice, leading ten regional offices developing and implementing legal strategies to protect our environment.

WOMEN AND THE ENVIRONMENTAL FUTURE

Women in elected office are often said to humanize the political agenda. A 2005 study of contemporary women's leadership by the management-consulting firm Caliper supported this view as did interviews with Washington women and men for this book. The Caliper study offers four findings about female leaders:

1. They tend to be more persuasive than male leaders, have strong people skills, read situations more accurately and listen more.
2. They learn from adversity—including frequent rejection—often with an "I'll show you" attitude.
3. They are more inclusive and more likely to build teams to solve problems and make decisions.
4. They are more likely to ignore rules and take risks.[183]

Female leaders also were found to be more empathic and flexible, as well as stronger in interpersonal skills than their male counterparts. "These qualities combine to create a leadership style that is inclusive, open, consensus building, collaborative and collegial," according to Caliper founder Herb Greenberg

These qualities helped leading Washington State conservation women to pierce the barrier of "economic think," where the only thing that mattered was conquering the earth and creating wealth—the future be damned. These women acted against the culture of the time; their strength came from banding together and forming networks that translated into votes and influence. Women may turn out to be ideal change agents to carry forward the comprehensive view that unites the health of humanity to a healthy environment that will sustain the world. We need this viewpoint even more now as more people compete for clean water and clean air and curbing greenhouse gases from fossil fuel emissions becomes ever more urgent.

When people talk about women's issues they usually talk about families, education and what can be referred to as "kitchen table" issues. The environment is almost never mentioned. But women have been at the forefront of protecting our natural resources and quality of life since the beginning of the twentieth century. Washington's former governor Christine Gregoire clearly made the connection between family and environment:

Originally when I became a lawyer, I was completely consumed with children and protecting children...when you have a commitment to children...there's a bridge over to thinking about the environment...and that's what happened. When I came over here [to Olympia] from Spokane as one of the supervising lawyers, everybody was asked what they wanted to supervise because no one was necessarily an expert, and I opted to supervise all the resource divisions, so parks, fisheries, wildlife, natural resources, ecology, agriculture became my responsibility, and that's probably when I got completely enmeshed in it...I didn't give up my passion for kids. I found the two to be absolutely married.

Much of the twentieth century in Washington State was dominated by industries set up to harvest trees and dig treasure: timber companies, mining companies, shipbuilders. The objective was to turn Washington's old-growth forests, precious metals and rivers into dollars as if there were no tomorrow. Natural resources were considered endless, even when it became increasingly clear to many that they were not.

The scorched-earth policy that unchecked development encourages is slowly giving way to a view that there are more environmentally sustainable ways to provide jobs and develop a strong economy. Economist Ed Whitelaw has called the spectacular mountains and rivers in Washington—its environment—the second paycheck. Businesses move to the state so that they can attract highly skilled and environmentally aware employees. Here is how Gregoire expressed this more comprehensive philosophy that could take us into the future:

I don't think you ought to pit the environment against the economy. I always will believe that a good environment is good for the economy, and a good economy is good for the environment. So we've got to find a way to translate. What I typically say to audiences is..."You don't actually think this is just about salmon, do you? If that salmon doesn't have enough water, if the water quality isn't good enough for that salmon, well, then, how come that water quality is good enough for us? Isn't that my drinking water?"[184]

NOTES

INTRODUCTION

1. Kimberly A. Jarvis, "Gender and Wilderness Conservation," in *American Wilderness: A New History*, edited by Michael Lewis (Oxford: Oxford University Press, 2007), 149–50.
2. Carsten Lien, *Olympic Battleground: Power Politics of Timber Preservation*, 2nd ed. (Seattle, WA: Sierra Club Books, 2000), 293.
3. Shanna Stevenson, *Women's Votes Women's Voices: The Campaign for Equal Rights in Washington* (Tacoma: Washington State Historical Society, 2009), 21.
4. Jarvis, "Gender and Wilderness Conservation."
5. Stephen Fox, *The American Conservation Movement: John Muir and His Legacy* (Boston: Little Brown, 1981), 343.
6. Polly Welts Kaufman, *National Parks and the Woman's Voice: A History* (Albuquerque: University of New Mexico Press, 1997), 30–32.
7. Fox, *American Conservation*, 343.
8. Aubrey L. Haines, *Mountain Fever: Historic Conquests of Rainier* (Seattle: University of Washington Press, 1999), 109.
9. Stevenson, *Women's Votes*, 75.
10. Fox, *American Conservation*, 344–45.
11. Stevenson, *Women's Votes*, 12.
12. Karen Fraser, interview by Dee Arntz, December 17, 2007, tape recording in author's possession. All quotes from Karen Fraser are from this source, unless otherwise noted.
13. Judy Turpin, interview by Dee Arntz and Raelene Gold, October 20, 2003, tape recording in author's possession.
14. Chris Smith Towne, interview by Dee Arntz, August 14, 2008, tape recording in author's possession.

15. Jolene Unsoeld, interview by Dee Arntz, March 19, 2008, tape recording in author's possession.

16. "Women in the Washington State Legislature," *Statistical Reports*, Washington State Legislature, Legislative Information Center, Statistical Reports, http://www.leg.wa.gov/LIC/Pages/stats.aspx (accessed May 16, 2012).

17. *Seattle Post Intelligencer*, "Women Politicians Moving Up After Decade of Grooming. It's a Banner Year for State's Candidates," March 22, 1992.

18. "Women in the Washington State Legislature."

19. Fox, *American Conservation*, 344.

20. Rod Brown, interview by Dee Arntz, November 25, 2007, tape recording in author's possession.

21. Marcy Golde, interview by Dee Arntz and Raelene Gold, December 20, 2002, tape recording in author's possession.

22. Nancy C. Unger, *Beyond Nature's Housekeepers: American Women in Environmental History* (Oxford: Oxford University Press, 2012).

23. Polly Dyer, "Preserving Washington Parklands and Wilderness," an oral history conducted in 1983 by Ann Lage, in *Pacific Northwest Conservationists*, Regional Oral History Office, University of California–Berkeley, Bancroft Library, 1986.

24. Helen Engle, *Letter to Donors*, National Audubon Appeal, 2006.

25. Ed Zuckerman, interview by Dee Arntz, September 11, 2009, tape recording in author's possession.

26. Dyer, "Preserving Washington."

27. Brown, interview.

28. Alice Shorett, interview by Dee Arntz, April 7, 2010, tape recording in author's possession.

29. Lynn Bayrich, interview by Dee Arntz, June 6, 2008, tape recording in author's possession.

CHAPTER 1

30. William Dietrich, *The Final Forest: The Battle for the Last Great Trees of the Pacific Northwest* (New York: Simon and Schuster, 1992), 180–81.

31. Carolyn Merchant, "Women of the Progressive Era Conservation Movement, 1900–1916," *Environmental Review* 8 (1984), 57.

32. Lien, *Olympic Battleground*, 42–45

33. Edna St. Vincent Millay, "God's World," in *Renascence and Other Poems* (New York: Harper & Brothers, 1917).

34. Polly Dyer, interview by Dee Arntz and Raelene Gold, December 7, 2001, tape recording in author's possession. All quotes from Polly Dyer are from this source, unless otherwise noted.

35. Douglas Brinkley, *The Wilderness Warrior: Theodore Roosevelt and the Crusade for America* (New York: Harper Collins, 2009): 306.

36. Irving Brant, *Adventures in Conservation with Franklin D. Roosevelt* (Flagstaff, AZ: Northland Publishing, 1988), 71–72.

37. Ibid., 72.

38. Ibid., 76.

39. Dyana Z. Furmansky, *Rosalie Edge, Hawk of Mercy: The Activist Who Saved Nature from the Conservationists* (Athens: University of Georgia Press, n.d.), 116–18.

40. Brant, *Adventures in Conservation*, 89.

41. Lien, *Olympic Battleground*, 196–98.

42. Brant, *Adventures in Conservation*, 312–13.

43. Emily Haig Papers, Special Collections, University of Washington Libraries, Seattle, Washington.

44. Robert Michael Pyle, "Foreword," in *John Muir's Last Journey: South to the Amazon and East to Africa*, edited by Michael P. Branch (New York: Island Press, 2001), xv–xviii.

45. Lien, *Olympic Battleground*, 298.

46. Undated manuscript, Box 2, Folder 6, Emily Haig Papers, Special Collections, University of Washington Libraries, Seattle, WA.

47. Mark Harvey, *Wilderness Forever: Howard Zahniser and the Path to the Wilderness Act* (Seattle: University of Washington Press, 2005), 203.

48. Ibid., 243.

49. Dyer, "Preserving Washington," 38.

50. Ibid., 36.

51. J. Michael McCloskey, *In the Thick of It: My Life in the Sierra Club* (New York: Island Press, 2005), 43–45.

52. Harvey Manning with the North Cascades Conservation Council, *Wilderness Alps: Conservation and Conflict in Washington's North Cascades* (Bellingham, WA: Northwest Wild Books, 2007), 188–89.

53. Ibid., 190–91.

54. Kevin R. Marsh, *Drawing Lines in the Forest: Creating Wilderness Areas in the Pacific Northwest* (Seattle: University of Washington Press, 2007): 58.

55. Karen Fant, interview by Raelene Gold, 2002, tape recording in private collection.

56. "A Summer Memory Shared." *Seattle Audubon Notes* 19, no. 1 (September 1978): 1.

CHAPTER 2

57. Dee Boersma, "Vim Wright," speech at Vim Wright's memorial service, video recording by Tom Putnam, June 22, 2003.

58. Joan Thomas, interview by Dee Arntz, July 1, 2009, tape recording in author's possession.

59. Ibid.

60. Rod Brown, interview with Dee Arntz, November 21, 2007, tape recording in author's possession.

61. Joan Thomas, interview by Dee Arntz and Raelene Gold, September 9, 2002, tape recording in author's possession.

62. Susan Starbuck, *Hazel Wolf: Fighting the Establishment* (Seattle: University of Washington Press, 2002), 23. Information about Hazel Wolfe's early life is taken from this source.

63. Maria Cantwell, interview by Dee Arntz and Raelene Gold, September 6, 2008, tape recording in author's possession.

64. Jeff Parsons, interview by Dee Arntz, September 11, 2009, tape recording in author's possession.

65. Delphine Haley, *Dorothy Stimson Bullitt: An Uncommon Life* (Seattle, WA: Sasquatch Books, 1995), 108.

66. Harriet Bullitt, interview by Dee Arntz, September 12, 2009, handwritten notes in the author's possession. All quotes from Harriet Bullitt are from this source unless otherwise noted.

67. *Seattle Post Intelligencer*, "Un-Damming Rivers: Two Who Fought for Salmon," January 29, 2011.

68. Denis Hayes, speech on the occasion of the 2004 Audubon Medal Dinner, Seattle, WA, transcript, October 3, 2004.

69. Boersma, "Vim Wright."

70. Vim Wright, *Vim Wright an Oral History*, tape recording by Nancy Dahl, April 2002. All quotes from Vim Wright are from this source unless otherwise noted.

71. Estella Leopold, interview by Dee Arntz and Raelene Gold, May 29, 2005, tape recording in author's possession. All quotes from Estella Leopold are from this source unless otherwise noted.

72. Jennifer Belcher, phone conversation with Dee Arntz, March 9, 2008.

73. Christine Gregoire, speech at Vim Wright's memorial service, video recording by Tom Putnam, June 22, 2003.

74. *Vim Wright an Oral History*

75. Estella Leopold, interview with Dee Arntz and Raelene Gold, October 20, 2009, tape recording in the author's possession.

76. Lynn Bayrich, interview by Dee Arntz, June 6, 2008, tape recording in the author's possession.

77. "Bullitt Foundation Board Member Honored for Lifetime Achievements," Bullitt Foundation News, http://bullitt.org/news/bullitt-foundation-board-member-honored-for-lifetime-achievements (accessed March 12, 2012).

78. Leopold, interview, 2009.

79. Estella Leopold, *Nina Leopold-Bradley and Estella Leopold: Daughters of Aldo Leopold*, oral history by Rick Lemmon, U.S. Fish and Wildlife Service, September 11, 2003, http://library.fws.gov/OH/leopold.nina.estalla.pdf (accessed May 16, 2012).

CHAPTER 3

80. "Warrior on Wheels," *Time Magazine*, December 14, 1998.

81. Bonnie Phillips, interview by Dee Arntz, July 9, 2009, tape recording in the author's possession. All quotes from Bonnie Phillips are from this source unless otherwise noted.

82. William Dietrich, *The Final Forest: The Battle for the Last Great Trees of the Pacific Northwest* (New York: Simon and Schuster, 1992), 248.

83. Brock Evans, telephone interview by Dee Arntz and Bríd Nowlan, September 17, 2010, tape recording in the author's possession.

84. Roger Parloff, "Liti-slating, How the Timber Industry Gets Its Local Congressman to Fix Its Cases," *American Lawyer* (January 1992): 80, in Victor M. Sher, "Surveying the Wreckage: Lessons from the 104th Congress," *Fordham Environmental Law Journal* 8, no. 3 (2011): 590.

85. George Hoberg, *Science, Politics and U.S. Forest Law: The Battle Over the Forest Service Planning Role,* Resources for the Future: Discussion Paper 03-19, June 2003, 5–6, http://EconPapers.repec.org/RePEc:rff:dpaper:dp-03-19 (accessed May 16, 2012).

86. Kathie Durbin, *Tree Hugger: Victory, Defeat and Renewal in the Northwest Ancient Forest Campaign* (Seattle, WA: Mountaineers Books, 2003), 86.

87. Ibid., 144.

88. "Memo to Old Growth Activists from Brock Evans RE Update," April 13, 1988, Audubon Washington files, Washington History Research Center, Tacoma, WA, hereafter called Audubon Washington files.

89. Ibid.

90. Durbin, *Tree Hugger*, 173.

91. Melanie Rowland, interview by Dee Arntz and Raelene Gold, April 10, 2008, tape recording in the author's possession. All quotes from Melanie Rowland are from this source unless otherwise noted.

92. "Report on National Audubon Society Adopt A Forest Ancient Forest Mapping Program," from Jim Pissot to Chuck Sisco, Jan 27, 1989, Audubon Washington files.

93. Keith Ervin, *Fragile Majesty: The Battle for North America's Last Great Forest* (Seattle, WA: Mountaineers Books, 1989), 197.

94. "Memo to Old Growth Activists," Audubon Washington files.

95. Shannon Peterson, *Acting for Endangered Species: The Statutory Ark* (Lawrence: University Press of Kansas, 2002), 99–100.

96. Peterson, *Acting for Endangered Species*, 87.

97. Ibid., 94.

98. Durbin, *Tree Hugger*, 123.

99. Peterson, *Acting for Endangered Species*, 99.

100. Ibid., 90–95.

101. Evans, interview, 2010.

102. Durbin, *Tree Hugger*, 205–09.

103. Ibid., 210.

104. Ibid., 228.

105. Edward A. Whitesell, ed., *Defending Wild Washington: A Citizens Action Guide* (Seattle, WA: Mountaineers Books, 2004), 190–91.

106. Durbin, *Tree Hugger*, 267–76.

107. Helen Engle, interview by Dee Arntz and Raelene Gold, May 3, 2005, tape recording in the author's possession. All quotes from Helen Engle are from this source unless otherwise noted.

108. Durbin, *Tree Hugger*, 279.

109. Ibid., 283.

110. Whitesell, *Defending Wild Washington*, 73.

111. Evans, interview, 2010.

CHAPTER 4

112. The Washington Office of Financial Management, *Creating Livable Communities Managing Washington's Growth for 15 Years* (Olympia: Washington State Department of Community, Trade, and Economic Development, 2006), 4–35.

113. "I was stuck in traffic…on my right-hand side [there] were a couple hundred new apartment units going in. I like apartments. I like higher density. But I wondered how the people were going to get to work, and I wondered who coordinated all this? Somebody must have taken into consideration the kind of impact the new residents will have on traffic and other impacts they will have on the community. Well, I looked into it and clearly there wasn't any coordination. So that was really the impetus for growth management." Joe King, interview by Rita R. Robison, in *Growth Management Acts 1990, 1991: A Collaborative Oral History Project* (Olympia, WA: Office of the Secretary of State, 2005), http://apps.leg.wa.gov/oralhistory/timeline_event.aspx?e=60 (accessed May 16, 2012). All quotes from Joe King are from this source unless otherwise noted.

114. Tom Campbell, interview, *Growth Management Acts*. All quotes from Tom Campbell are from this source unless otherwise noted.

115. Senator Maria Cantwell, interview by Dee Arntz and Raelene Gold, September 6, 2008, tape recording in the author's possession. All quotes from Senator Cantwell are from this source unless otherwise noted.

116. Jennifer Belcher, interview, *Growth Management Acts*. All quotes from Jennifer Belcher in this chapter are from this source unless otherwise noted.

117. Busse Nutley, interview, *Growth Management Acts*, 2005. All quotes from Busse Nutley are from this source unless otherwise noted.

118. *Seattle Times*, "Longtime Legislator Ruth Fisher Dies," February 23, 2005.

119. Nancy Rust, interview by Dee Arntz and Raelene Gold, March 22, 2004, tape recording in the author's possession. All quotes from Nancy Rust are from this source unless otherwise noted.

120. Mary Margaret Haugen, interview by Diane Wiatr, in *Growth Management Acts*, 2005.

121. Lucy Steers, interview by Dee Arntz, July 28, 2008, tape recording in the author's possession.

122. "Four Corners Letter, September 28, 1990," in *Growth Management Acts*, 2005.

123. Wayne Ehlers, interview by Diane Wiatr, in *Growth Management Acts*, 2005.

124. Ibid.

125. *Seattle Times*, "Promises Kept—King and Hayner Deliver a Growth Bill in Olympia," June 30, 1991.

126. Dee J. Frankfourth, Andrew Grow and Patrick C. Higgins, *The 1995 Takings Campaign in Washington State: A Report and Analysis on the Referendum 48 Campaign* (Seattle, WA: Washington Environmental Alliance for Voter Education, 1996), 30.

127. Frankfourth, Grow and Higgins, *1995 Takings Campaign*.

128. *Seattle Times*, "R-48: Wrong Solution to a Serious Concern," October 6, 1995.

Chapter 5

129. Forest Study Committee, *Washington's Dynamic Forests: A Study of Forests and Forest Issues*, Seattle (League of Women Voters Education Fund, 1998), 5–6.

130. William Dietrich, *The Final Forest: The Battle for the Last Great Trees of the Pacific Northwest* (New York: Simon and Schuster, 1992), 180.

131. Ibid.

132. Ibid., 184.

133. Marcy Golde, interview by Dee Arntz and Raelene Gold, September 8, 2003, tape recording in the author's possession. All quotes from Marcy Golde are from this source unless otherwise noted.

134. Dietrich, *Final Forest*, 96.

135. Marcy Golde, interview in Washington Environmental Council 30th Anniversary Celebration Video of Board Members, Part 1, Washington Environmental Council, unpublished video recording, 1998.

136. *Review of the 29 April 1999 "Forests and Fish Report" and of Associated "Draft Emergency Forest Practices Rules"* (Seattle: Society for Ecological Restoration Northwest Chapter and the Western Division of the American Fisheries Society, 2000), 34.

137. Colleen Lee, "Letter to Representative Jim Buck, May 10, 1999," in *Criticism of the Forest and Fish Report Is Widespread*, Forest and Fish Conservation Caucus Memo, July 17, 2009.

138. State senator Darlene Fairley, "Letter to Constituents Containing Comments on the Adaptive Management Program for the 9.3 Million Acre Washington Forest Practices Habitat Conservation Plan, May 6, 1999," in *Criticism of the Forest and Fish Report*.

139. Jennifer Belcher, interview by Dee Arntz and Raelene Gold, January 11, 2002, tape recording in the author's possession. All quotes from Jennifer Belcher in this chapter are from this interview unless otherwise noted.

140. *Seattle Post-Intelligencer*, "The Money Tree: Selling Trust Lands," June 6, 1996.

Chapter 6

141. Maria McLeod, *Historically Speaking: An Oral History in Celebration of the first 35 years, 1970–2005* (Olympia: Washington State Department of Ecology, 2005), 23–29.

142. "Hanford Superfund Site History," U.S. Environmental Protection Agency, Region 10, http://yosemite.epa.gov/R10/CLEANUP.NSF/0903AE66D99736 E188256F04006C2D3A/045F8399CAA1B6BD882573FC0069B078?OpenDo cument (accessed September 20, 2013).

143. Roy E. Gephart, *Hanford: A Conversation About Nuclear Waste and Cleanup* (Columbus, OH: Battelle Press, 2003), 2.3–5.12

144. Ibid., 2.24–2.25.

145. McLeod, *Historically Speaking*, 26.

146. "History of RCRA," Environmental Protection Agency website, http://www.epa.gov/epawaste/laws-regs/rcrahistory.htm (accessed September 30, 2013).

147. "Superfund: Taking on the Nation's Hazardous Waste Challenge," U.S. Environmental Protection Agency, http://www.epa.gov/superfund/accomp/17yrrept (accessed September 30, 2013).

148. Jolene Unsoeld, "History, Art & Archives, United States House of Representatives," http://history.house.gov/People/Detail/20851?ret=True (accessed September 20, 2013).

149. "Jolene Unsoeld," in *Women in Congress, 1917–2006*, prepared under the direction of the Committee on House Administration by the Office of History & Preservation, U.S. House of Representatives (Washington, D.C.: Government Printing Office, 2006), http://bioguide.congress.gov/scripts/biodisplay.pl?index=U000017 (accessed September 20, 2013).

150. Ibid.

151. Laurence Leamer, *Ascent: The Spiritual and Physical Quest of Legendary Mountaineer Willi Unsoeld* (New York: Harper Collins, 1999), 21.

152. Rod Brown, interview by Dee Arntz, November 25, 2007, tape recording in the author's possession. All quotes from Rod Brown are from this source unless otherwise noted.

153. Nancy Rust, interview in Washington Environmental Council 30th Anniversary Celebration Video of Board Members, Part 2, Washington Environmental Council, unpublished video recording, 1998.

154. David Bricklin, interview by Dee Arntz, January 23, 2008, tape recording in the author's possession.

155. Sheri Tonn, interview by Dee Arntz, March 20, 2009, tape recording in the author's possession. All quotes from Sheri Tonn are from this source unless otherwise noted.

156. *Commencement Bay, Nearshore/Tideflats, Washington, EPA ID# WAD980726368,* U.S. Environmental Protection Agency, http://yosemite.epa.gov/r10/nplpad.nsf/0/06e1c0cda0d11fc285256594007559fd!OpenDocument (accessed October 10, 2013).

157. McLeod, *Historically Speaking*, 366–70.

158. Christine Gregoire, interview by Dee Arntz and Raelene Gold, December 19, 2003, tape recording in the author's possession. All quotes from Christine Gregoire are from this source unless otherwise noted.

159. McLeod, *Historically Speaking*, 372.

160. Jay Manning, interview by Dee Arntz and Raelene Gold, December 13, 2007, tape recording in the author's possession. All quotes from Jay Manning are from this source unless otherwise noted.

161. "Gov. Gregoire Announces New Initiative to Create Jobs, Restore Puget Sound," Governor's Office Press Release, December 9, 2011, http://www.governor.wa.gov/news/news-view.asp?pressRelease=1815&newsType=1 (accessed May 17, 2012).

162. "Washington Toxics Coalition," Seattle Foundation, http://www.seattlefoundation.org/npos/Pages/WashingtonToxicsCoalition.aspx (accessed September 20, 2013).

CHAPTER 7

163. Margaret McKenny, "Letter to Supporters," Nisqually Delta Association archives, Evergreen State College, Olympia, WA, 1996.

164. Helen Engle, interview by Dee Arntz and Raelene Gold, May 3, 2005, tape recording in the author's possession. All quotes from Helen Engle are from this source unless otherwise noted.

165. Helen Engle, personal communication, e-mail to author, December 16, 2010.

166. Belcher, interview by Dee Arntz and Raelene Gold.

167. M. Daheim, "The Nisqually Delta: Living Tideland for Wildlife," *Pacific Search Magazine*, September 1973, 9–10.

168. Mary Martin, interview by Dee Arntz, May 14, 2009, tape recording in the author's possession. All quotes from Mary Martin are from this source unless otherwise noted.

169. John A. Biggs, director, Department of Ecology, letter to the City of DuPont approving the Shoreline Management Plan, Nisqually Delta Association archives, Evergreen State College, Olympia, WA, 1975.

170. David Bricklin, interview by Dee Arntz, January 23, 2008, tape recording in the author's possession.

171. Dee Arntz, interview by Raelene Gold, October 19, 2006, tape recording in the author's possession.

172. *News Tribune*, "Nisqually Awaits Its Fate," March 27, 1994.

173. *Seattle Times*, "Peace on the Nisqually," August 29, 1994.

174. Janet Dawes interview in Washington Environmental Council 30th Anniversary Celebration Video, Part 2, Washington Environmental Council, unpublished video recording, 1998.

175. Nisqually River Council, *Nisqually Watershed Stewardship Plan*, 2009, 3.

176. Nisqually Land Trust, *2009–2010 Annual Report*, www.NisquallyLandTrust. org/documents/AnnualReport09-10Final.pdf (accessed January 25, 2011).

CHAPTER 8

177. *Seattle Times*, "Women March on Washington—As Candidates," March 26, 1992.

178. Nancy Schatz Alton, "Washington's Women in Politics Lead the Way: Their Sacrifices and Successes Make Life Better for Women and Families," *Elect Women*, April 21, 2009, http://electwomen.com/2009/04/washingtons-women-politics-lead-way/ (accessed June 21, 2010).

179. Bríd Nowlan, *Women in Leadership in Environmental Groups in Washington State, Survey*, 2010, unpublished, in possession of the author.

180. Kathy Fletcher, interview by Dee Arntz and Raelene Gold, March 18, 2005, tape recording in the author's possession.

181. Joan Crooks, interview by Dee Arntz and Raelene Gold, July 26, 2005, tape recording in the author's possession.

182. Martha Kongsgaard, interview by Dee Arntz and Raelene Gold, November 10, 2007, tape recording in the author's possession.

183. "The Qualities that Distinguish Women Leaders," Caliper, https://www.calipercorp.com/portfolio/the-qualities-that-distinguish-women-leaders/ (accessed September 30, 2013).

184. Christine Gregoire, interview by Rod Brown, February 1, 2001, tape recording.

INDEX

ABOUT THE AUTHOR

Dee Arntz has a certificate in wetland science from the University of Washington, a master's in anthropology from San Francisco State and a BA in political science from Boston College. She is a writer and a member of the Audubon Society, a former board member of Seattle Audubon and the former chair of that group's nationally recognized Washington Wetlands Network. She has also served as board member of the Audobon Washington and Washington Environmental Council.

Dee Arntz. *Rozarii Lynch.*